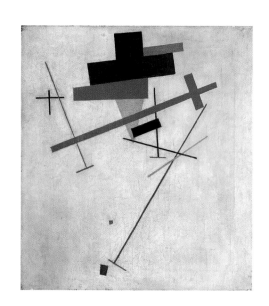

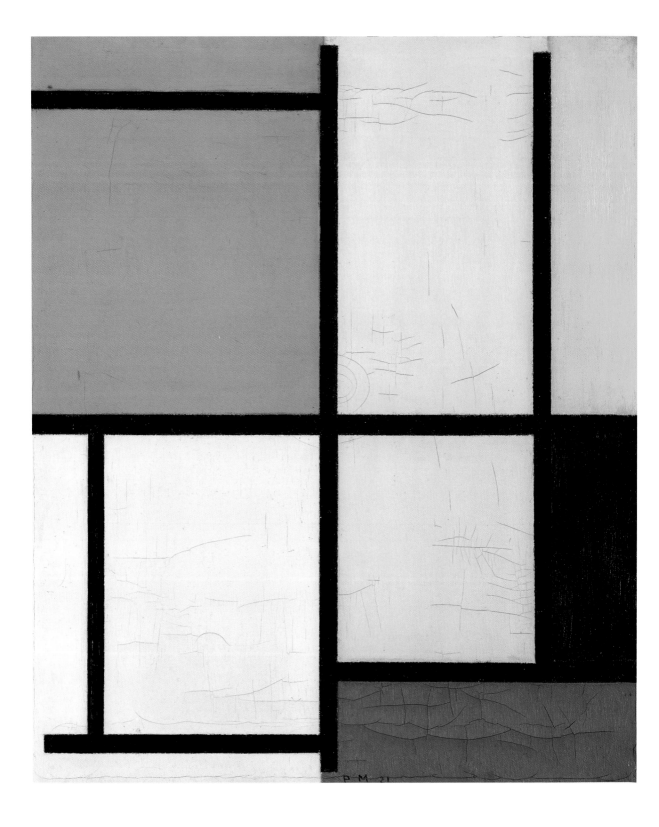

abstract Art

DIETMAR ELGER
UTA GROSENICK (ED.)

TASCHEN

HONG KONG KÖLN LONDON LOS ANGELES MADRID PARIS TOKYO

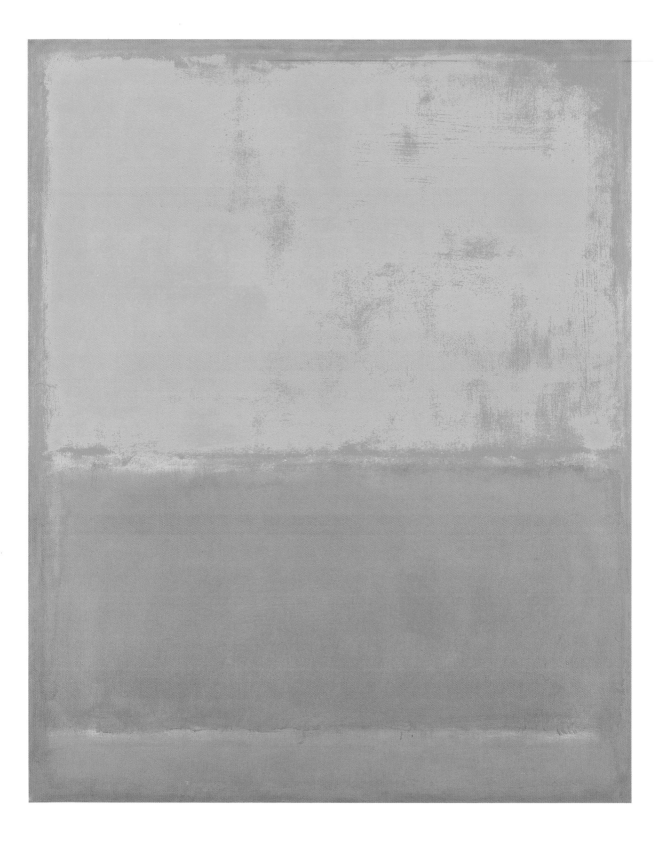

contents

The Art of Painting Autonomous symbols

"Abstract paintings must be as real as those created by the sixteenth century Italians."

Frank Stella

The triumph of abstraction is inseparably connected with the general development of art in the twentieth century. Formulating a world view freed from any dependence on objects was the most prominent achievement of twentieth century art. This art had previously been mimetic: it portrayed the world as it appeared to the artist. Even when pictures visualized abstract ideas and concepts, they did so using the tools of representational painting. Illustrations of courage, faithfulness, or unity were visualized for the viewer as personified virtues. Complex themes were depicted with skilfully composed groups of figures, or through idealised landscapes. Not until the beginning of the twentieth century did artists such as Pablo Picasso in Paris, Wassily Kandinsky in Munich, and Kasimir Malevich in Moscow begin to dissolve concrete objects, making the transition to the art of painting autonomous symbols.

Hieratic- and central perspective

Concepts such as realism and abstraction are questionable in painting. The hieratic perspective of medieval painting, in which the size of every object on the picture plane is proportional to the importance attributed to the object, was replaced in the early Renaissance by one-point perspective; pictorial space was transformed from idealistic to illusionistic. Observers experienced the painted surface from then on as a view out of a window and into the visible world. In extreme cases, painters used so much skill to create this illusion that viewers would actually be deceived by the painted scene, and would gain the impression that they could see a real three-dimensional object on the picture plane. Apart from such idiosyncratically playful trompe-l'œil effects of painting based on optical illusion, all painting styles are always simultaneously an abstraction. In fact, representational painting never attains an independent quality, but remains only a fabrication distilled from reality by referencing that reality and attempting to portray it. Representational painting, however, can never be reality itself.

1910 — Sigmund Freud publishes "About Psychoanalysis" 1910 — Wassily Kandinsky paints his first abstract watercolour

1910 — Publication of the "Manifesto of Futurist Painting"

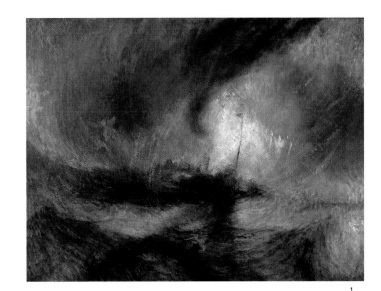

1. WILLIAM TURNER

Snow Storm – Steam Boat off a Harbour's
Mouth making Signals in Shallow Water, and
going by the Lead. The Author was in this
Storm on the Night the Ariel left Harwich
1842, oil on canvas, 91.5 x 122 cm
Tate Britain, London

1

It was precisely in view of this type of intellectual approach that abstract painting offered new and unsuspected possibilities. It could be autonomous, and did not have to refer to a known reality. Indeed, abstract painting functioned instead as an analogy to an unknown world. Its painterly elements stood first and foremost for themselves. If a blue area is no longer read as depicting the sea, and a horizontal line no longer marks a horizon, art may lose its quality as an analogy, but thereby it gains independence and assertiveness. The moment paint becomes free to accentuate its quality as a colour and not just to act as, for example, a flesh tone colouring an object, it gains an independent quality never before known in painting. The entire intensity, radiance, and spatiality of that patch of colour can now act upon the viewer. Here the paint can be perceived as real paint, and thereby becomes more realistic than in any painting by the classical masters praised for the precision of their depictions of reality, such as Leonardo da Vinci, Jan Vermeer, or Jean Auguste Ingres, to name three painters from three different schools and centuries as examples.

"What you see is what you see" as the American painter Frank Stella, speaking in the nineteen sixties, pragmatically and succinctly formulated this factual and objective nature of the materials of painting. Concepts such as "realistic" or "abstract" can certainly not be defined as clearly and precisely as may seem at first to be the case. In truth, every painted representational depiction is an illustration done from a model in nature, and is thereby simultaneously an abstraction of that model. Just in the fact that painting projects three-dimensional models onto a flat plane, it necessarily changes and defamiliarizes these models as well. Non-objective painting avoids this reduction of dimensions. It does not portray, but instead creates its compositions out of flat forms like squares, rectangles, and circles. Provided that these arrangements of forms are not in turn organized into representational associations, we must accept the apparently paradoxical result that the putatively non-objective representation is the more realistic one, while all depictions generally described as realistic are completely incapable of overcoming their status as an abstraction of reality.

In fact the transitions between the two categories are fluid, and their boundaries are by no means as clear as the two antithetical concepts would lead one to think. Both approaches have tested again

1910 — Herwarth Walden publishes "Der Sturm" [The Storm]
the Spiritual in Art"

1911 — Wassily Kandinsky publishes "Concerning

1911 — Opening of the first Blue Rider exhibition in the Galerie Thannhauser in Munich

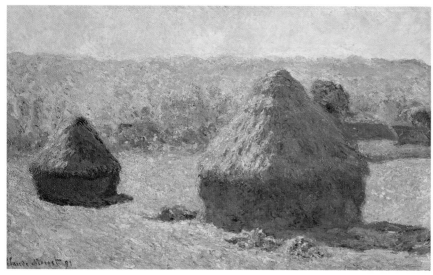

2. CLAUDE MONET

<u>Haystacks at the End of Summer</u>
1890, oil on canvas, 60 x 100 cm
Musée d'Orsay, Paris

3. PAUL CÉZANNE

<u>Monte Sainte-Victoire</u>
1902–1904, oil on canvas, 73 x 91.9 cm
Philadelphia Museum of Art,
The George W. Elkins Collection

2

and again the boundaries between painterly representation and abstraction. In 1842 the English landscape painter William Turner captured the motif *Snow Storm – Steam Boat off a Harbour's Mouth* in a stirring composition: sea, storm, snow, and clouds are interwoven here in a dizzying whirlpool. The helpless ship, the turbulent sea, and the churning clouds can hardly be distinguished from one another. Turner's depiction far exceeds a mere portrayal of the catastrophe or a painterly formulation of the objects. The paint and the brush strokes swirl with great dynamics, rhythm, and drama across the canvas. Here the landscape dissolves in the material of the paint, and yet the pulsating swirls of colour are what evoke an association with the stormy sea in the first place. What begins to manifest itself here is an equilibrium in which realistic depiction tips towards autonomous painting, and this autonomous colouration condenses into an impression of landscape.

The Nineteenth-century conquest of visual Abstraction

In 1890 the French painter Maurice Denis declared: "A painting, before being a warhorse, a naked woman, or some anecdote or other, is essentially a flat surface covered with colours in a particular arrangement." Denis was thus an early proponent of the primacy of painterly means over their representational function. In abstract painting, the painted colours and forms ultimately manage without the reference system of the exterior world of objects. Sometimes even misperceptions have helped the development of this type of abstract perspective. In 1895, when he was twenty nine, Wassily Kandinsky visited an exhibition in Moscow by the French Impressionists. Here he found himself directly faced with one of Claude Monet's famous *Haystack* paintings, but did not immediately recognize the motif. Initially, Kandinsky was merely enthusiastic about the delicate coloration, the radiance of which at first upstaged the representational motif. Still another experience sharpened Kandinsky's recognition of the autonomous compositional qualities of form and colour. One day

1911/12 — Die Pittura metafisica established around Giorgio de Chirico, Carlo Carrà, and Giorgio Morandi 1912 — Guillaume Apollinaire coins the term Orphism 1913 — In New York the "Armory Show" opens – the first large international exhibition of modern art

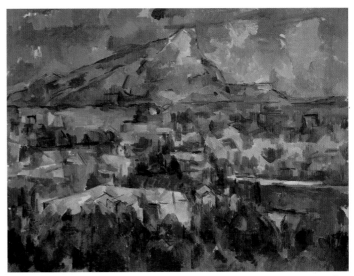

"Art is harmony parallel to nature."

Paul Cézanne

around ten years later, by which time Kandinsky was living in Munich, he noticed a strange painting in his studio, and his attention was immediately captivated by the free painterly rhythm of the work's forms. It wasn't until a moment later that he recognized the unknown composition as one of his own paintings that had simply been placed upside down. Both episodes encouraged Kandinsky to leave the world of representational motifs behind him some years later, and to conceive of painting as the pictorial organization of free colours and forms that were no longer bound to any object.

The story from Kandinsky's studio also makes one think of the work of the contemporary German painter Georg Baselitz, who began to compose his figurative motifs upside down at the end of the nineteen sixties. The aesthetic experience sought is the same as that which had previously presented itself in Kandinsky's work, then still unwittingly. The viewer's interest is intentionally directed towards the autonomous qualities of colour and composition, and the figurative motif is simply a formal framework giving the colours stability and structure. Baselitz employs colours, forms, and gestural brush strokes in a manner similar to that of an abstract painter. The motif prevents him, however, from arbitrariness in the composition. While the transition between representational and abstract painting is already permeable, Baselitz takes a decisive step further, proving that an abstract painting style is even possible when the motif is representational.

From this position we must once again look back an entire century. The systematic conquest of an abstract world of imagery had its beginnings in Paul Cézanne's landscapes and still lifes. He reordered the priorities within pictorial composition by no longer formulating nature as a model, but deconstructing it instead into an analytical structure of stereometric spatial units. According to one of the artist's most famous principles, all objects in nature are shaped like spheres, cylinders, and cones. For his painting style Cézanne thereby formulated a premise he had derived from an abstract vocabulary. He no longer wished to illustrate, and thus simply *reproduce* the landscapes and still lifes of visible nature, but rather to *represent* them: that is, to transform them into an autonomous painterly equivalent. Correspondingly, another no less famous artistic maxim of Cézanne's reads: "Art is a harmony parallel to nature."

1914 — Beginning of the First World War 1915 — Albert Einstein formulates his General Theory of Relativity
1916 — Hugo Ball founds the Dadaist Cabaret Voltaire in Zurich

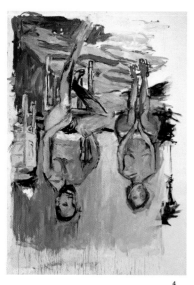

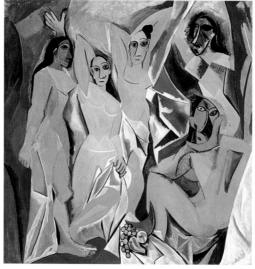

4. GEORG BASELITZ

<u>Schlafzimmer (Bedroom)</u>
1975, oil and charcoal on canvas,
350 x 250 cm
Museum Ludwig, Cologne

5. PABLO PICASSO

<u>Les Demoiselles d'Avignon</u>
1907, oil on canvas, 243.9 x 233.7 cm
The Museum of Modern Art, acquired
through the Lillie P. Bliss Bequest, New York

4 5

"In a painting by Raphael it is not possible to determine the distance between the tip of the nose and the mouth. I want to paint pictures in which that will be possible."

Pablo Picasso

"Pictures with Little cubes"

Paul Cézanne's ideas became a crucial inspiration for following generations. Although his pictures always remained representational, Cézanne managed to formulate a conception of painting that freed the painted motif from its dependency on reality as a model. According to Cézanne's credo, art and nature present themselves to viewers as two parallel harmonies, existing alongside one another and thereby being equal. A few decades later, this upward revaluation of the substance of painting itself also fascinated the young Spaniard Pablo Picasso. Cézanne's artistic conception was one of the things that inspired Picasso to develop cubism, undeterred by the lack of understanding of most of his artist colleagues and friends. Picasso went a decisive step further than his father figure Cézanne, by understanding the painted motif not just as something that exists in parallel with natural phenomenon, but also as a reality detached from nature and existing in its own right. Picasso formulated his expanded aspirations in a pointed comparison: "In a painting by Raphael it is not possible to determine the distance between the tip of the nose and the mouth. I

want to paint pictures in which that will be possible." Cubism accomplished a final and radical break with the illusionistic, one-point-perspective-based style of painting that had been relied upon for centuries.

In the summer of 1907 Picasso completed his epochal painting *Les Demoiselles d'Avignon*. A few months later the painter Georges Braque saw this large-format composition. Braque was one of the few visitors to his friend Picasso's studio to understand that artist's compositions, and for whom the work would become a decisive inspiration in his own artistic development. In the autumn of the following year, when Braque submitted his new landscapes depicting austere, blocky architecture to the Salon d'Automne in Paris, the critic Louis Vauxcelles spoke disparaging of "pictures with little cubes". Thus a new artistic style once again received its name out of ignorance.

From that time onward Picasso and Braque developed cubism together, in sportsmanlike competition. The painted results were sometimes so similar that their works could hardly be distinguished from one another. During Cubism's first so-called analytical phase, the two artists withheld colour from their paintings and concentrated ent-

1917 — Theo van Doesburg and Piet Mondrian found the group and publication "De Stijl"
1917 — Declaration of war by the United States on the German Reich 1917 — October Revolution in Russia

6. PABLO PICASSO

<u>Pipe, Glass, Bottle of Vieux Marc</u>
1914, paper collage, charcoal, india ink,
printer's ink, graphite, gouache on canvas,
73.2 x 59.4 cm
Peggy Guggenheim Collection, Venice

7. EL LISSITZKY

<u>Composition</u>
1919, oil on canvas, 71 x 58 cm
National Art Museum of Ukraine, Kiew

6 7

irely on developing an innovative vocabulary of form. The cubic volumes in their works gradually gave way to the forms and fragments of geometric planes. By 1911 they had fully formulated this new pictorial language. Analytical cubism disassembled visible reality into a faceted structure of symbols. Picasso and Braque gave up a unified one-point perspective in favour of a plurality of perspectives.

In the next phase called Synthetic Cubism, which began in 1912, Picasso employed these forms as elementary symbols for objects. A guitar could be represented by two parallel lines cutting through a circular form, for example, and a glass by a triangle. Picasso had developed this reduced symbolic language in the foregoing phase, Analytical Cubism, in a lengthy process of abstraction. He now combined his painting style with fragments of reality, pasting newspaper pages, sheets from notebooks, or pieces of wallpaper into his compositions. It is in the most abstract examples of such motifs, created between 1913 and 1914, that reality is paradoxically present to a greater degree than in any of his other works – no longer in the sense of a mimetic imitation of nature, but as real objects collaged into the paintings.

The Logical Path Toward Abstraction

Cubism was the first innovative artistic current of the still nascent twentieth century. It stands as an example of the art of a modern industrial epoch and new scientific world view. Accordingly, Cubist work should also be understood as a perceptual model of our changed reality. It was at the beginning of the twentieth century that the physical world view underwent its most revolutionary expansion. New theoretical models and empirical research forced people to acknowledge some physical phenomena that evaded clear comprehension and logical understanding. "The social function of the great poets and great painters is to constantly renew the exterior image that nature assumes in the eyes of mankind", as the writer Guillaume Apollinaire demanded of literati and artists in his 1913 book "The Cubist Painters". This correlation between scientific insight and the aesthetic compositions of art can be understood if one examines the subject of investigation they have in common. Physics and the plastic arts are both concerned with the perception and knowledge of reality, even though they use different means to further their inquiries.

1918 — The Armistice between the German Reich and the Allies ends the First World War
1919 — Architect Walter Gropius founds the Bauhaus in Weimar

8

9

> **"Blue is the male principle, severe and spiritual.**
> **Yellow the female principle, gentle, cheerful and sensual.**
> **Red is matter, brutal and heavy and always the colour**
> **which must be fought and vanquished by the other two."**

Franz Marc

It is difficult to estimate the extent and depth of the Cubists' understanding of the radical changes in modern physics and chemistry. In 1981 Werner Spies, one of the most thoroughly informed experts on Picasso's work, expressed his conviction that "in this appeal to a sense of aesthetics that largely evades opinion, one also has to see the influence of the scientific discoveries of the period." Apollinaire, who being a comrade of the Cubist painters was one of very few contemporary sources, also wrote the following about his artist friends in 1913: "The new painters have just as little intention of being mathematicians as their predecessors had. Yet one can say that geometry to the plastic arts is what grammar is to writing. Yet today scholars no longer cling to the three dimensions of Euclidean geometry. Very naturally and almost intuitively, painters have been induced to concern themselves with the new achievable magnitudes – magnitudes collectively abbreviated in the language of the modern studio by the term *the fourth dimension.*" Thus the logical path towards abstraction was preordained for artists – and this was not just limited to the Cubists.

Plurality of perspectives

Since the beginning of the twentieth century, the modern world has become altogether more complex and abstract. A full and direct description of it is becoming more and more difficult; only a fragmentary view of this reality is now possible. That the viewer may occupy a neutral position outside the system being observed is an idea that no longer corresponds to existing realities. To artists of the twentieth century, central-perspective paintings with their fixed vanishing points represented an outmoded worldview that they wanted to replace with a new vocabulary of form.

For the first time, Cubist paintings showed a dynamic view of the world with an infinite number of constantly changing viewpoints that directly incorporated the observer into the depiction. A similar plurality of perspectives can be found later in the compositions of the Russian Constructivist El Lissitzky. The monumental formats created by the American painters Jackson Pollock and Barnett Newman in the nineteen fifties also reveal an intention to directly include viewers in their pictures.

1919 — "Dada Manifesto" published in Berlin; the magazine "Der Dada" founded by Raoul Hausmann

1920 — First meeting of the League of Nations in Geneva 1922 — Benito Mussolini becomes Italian Prime Minister

8. ROBERT DELAUNAY

<u>Simultaneous Windows to the City</u>
<u>(1st Part, 2nd Motif, 1st Replica)</u>
1912, oil on canvas on wood, 46 x 40 cm
Hamburger Kunsthalle, Hamburg

9. WASSILY KANDINSKY

<u>Improvisation "Gorge"</u>
1914, oil on canvas, 110 x 110 cm
Städtische Galerie im Lenbachhaus, Munich

10. FRANZ MARC

<u>Fighting Forms</u>
1914, oil on canvas, 91 x 131.5 cm
Pinakothek der Moderne, Munich

The breakthrough to abstraction in European painting was in the air around 1913. Wassily Kandinsky in Munich, Kasimir Malevich in Moscow, and Robert Delaunay and Frantisek Kupka in Paris each created their own unique pictorial solutions thereby. They did have the odd precursor, yet the work of these artists nonetheless remained a unique experiment, and at the time they were largely unknown or had little influence on younger generations. As early as 1905 Adolf Hölzel experimented with the first abstract compositions. Some abstraction can also be found four years later in the work of Francis Picabia, but these were barely noticed, and the artist did not pursue them further. Later, the expressionist August Macke, from the Rhineland, had a similar experience. In a 1907 letter he reported on his artistic idea, "to combine colours on a panel, without thinking about a real object." Yet such experiments did not find their way into his painting practice. At the time Macke must also have considered them too foolhardy to be worth developing into an acceptable artistic concept.

An intentional influence upon the Human soul

The situation and the general artistic climate were completely different half a decade later. Wassily Kandinsky proved to be the crucial personality in this, and it was to him that the invention of abstract painting was ascribed for several decades, citing a watercolour dated 1910. Although that watercolour had actually been produced three years later than Kandinsky asserted, this Russian artist living in Munich had consistently pursued his concept of painterly abstraction, and had promoted it publicly. As well, he supported the practical development of his painting style with a theoretical document. In 1912 his manifest "Über das Geistige in der Kunst" (Concerning the Spiritual in Art), written two years earlier, was published. As a requirement of the new art form he stated in this document: "The harmonies of colour and form must be based solely on the principle of exercising an intentional influence upon the human soul."

At the same time he described a fundamental difference from the works of Picasso and his comrade Braque: Forms and colours were no longer to be derived from an idea of nature, but created sole-

1922 — Founding of the Soviet Union 1923 — First Party Congress of the NSDAP in Munich
1924 — Death of the Soviet head of government Vladimir I. Lenin

11
 12

ly within the artist. The French Cubists' almost scientifically analytical approach was replaced in Kandinsky's works in Munich, but also in those of Robert Delaunay in Paris, by the emotional power of colour. From then on colour was no longer bound to a formal compositional framework, but instead could be employed freely and dramatically in a purely expressive manner. *Abstract* music, one of its precursors, became a crucial stimulus, and not only for Kandinsky. Artists found an equivalent to their paintings in the contemporary music of composers such as Arnold Schönberg and Igor Stravinsky, and they also used rhythm, sound, dynamics, and harmonies in their pictorial compositions. Accordingly, Kandinsky subdivided his works into *impressions*, *improvisations*, and *abstractions*; concepts with which he simultaneously described his painting style's increasing degree of abstraction.

In 1913, after Kandinsky had long clung to landscape allusions in his compositions, he created his first purely non-objective, large-format painting. Franz Marc, together with whom he published the almanac "Der Blaue Reiter" (The Blue Rider) in 1912, was the only Expressionist in Germany to follow him along this path. Marc's *form* paintings, which he also began creating in 1913, ascribe a central

place in their compositions to colour dynamics. A work such as *Fighting Forms* of 1914, however, also shows the difference between Marc's approach and that of Kandinsky. Here, red and black remained tied to prismatically broken but compact formal elements. Like the Cubists, Marc also placed his abstract painting in relationship to the modern scientific world order. "The coming art form", as he formulated in his aphorisms, "shall be our scientific convictions taking form; these are our religion, our central focus, our truth."

Pure colour нarmonies

At the same time, Orphism developed in Paris. Guillaume Apollinaire, the Cubists' comrade, gave the movement its name. Apollinaire coined the term in reference to the mythical singer Orpheus and to the musical harmony of painting. Robert Delaunay was the leading personality of this group in which Francis Picabia, Jean Metzinger, Albert Gleizes, and Fernand Léger also participated for a short time. The movement's initial impetus came in February 1912 from the Ital-

1924 — Kasimir Malevich publishes the "Suprematist Manifesto"
1924 — André Breton publishes the "Surrealist Manifesto" 1925 — The Bauhaus moves to Dessau under political pressure

11. FERNAND LÉGER

Smoke
1912, oil on canvas, 92 x 73 cm
Albright-Knox Art Gallery, Buffalo

12. CARLO CARRÀ

Rhythm of Objects
1911, oil on canvas, 53 x 67 cm
Pinacoteca di Brera, Milan

13. UMBERTO BOCCIONI

Dynamism of a Soccer Player
1913, oil on canvas, 193.2 x 201 cm
The Museum of Modern Art, New York

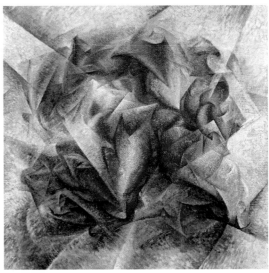

13

ian Futurists' exhibition in the Galerie Bernheim in Paris. The dynamic space-time compositions of painters such as Umberto Boccioni and Carlo Carrà brought the Orphists together with the cubic spatial interweaving of the French Cubists. Colour thereby took on new and prominent significance, for unlike the Cubists, Delaunay started primarily from coloration, and attempted to give it form. In his *Window* series, created in 1912, the urban architecture still appears in prismatically broken colours. "As long as art does not break free from the object it remains description", Delaunay noted. He avoided this descriptive function of painting more and more in favour of pure colour harmonies. From then on his pictures were based upon simultaneous colour contrasts as Delaunay began to unite colour, light, and rhythm within abstract compositions made up of centric circles.

The invention of the *Black square*

During the 1910s Moscow offered a more comprehensive opportunity than any other place for artists to inform themselves about current developments in painting. Not even in Paris itself would young painters have been able to study more than the twenty four pictures by Cézanne and fifty one works by Picasso collected there, and to measure their own works against them. As early as 1905 the two Moscow merchants Sergei Shchukin and Ivan Morozov were among the most progressive collectors of contemporary French painting. In addition to the works by Cézanne and Picasso, many paintings by Henri Matisse, Paul Gauguin, and Claude Monet also made their way to Russia at that time. Moreover, the two collectors made their grand villas accessible to artists, who were eager to learn. At the same time several progressive artists' periodicals published information in Moscow about the contemporary Parisian art scene.

Kasimir Malevich also took advantage of such opportunities, using these western influences to inform his own art. When he arrived in the capital in 1904 his painting style was still entirely bound to the Russian folk-art tradition. After 1911, however, his work developed rapidly towards non-objectivity. Cézanne, Picasso, and Italian Futurism became Malevich's role models. He also made the personal acquaintance of the Italian poet and theoretician Filippo Tommaso Marinetti

1928 — "An Andalusian Dog" by Luis Buñuel and Salvador Dalí premiers in Paris 1929 — "Black Friday" on the New York Stock Exchange heralds the Great Depression 1929 — Founding of the Museum of Modern Art in New York

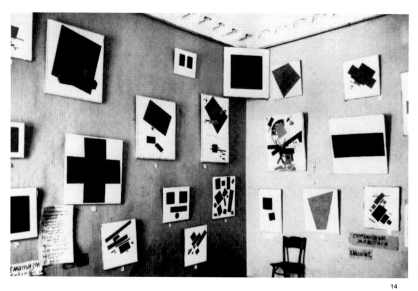

14.
Photograph of the last Futuristic exhibition "0.10" (null-ten) in the Nadjeschda Dobychina Gallery in St. Petersburg, 1915/16

14

"The efforts were not aimed at presenting the object in its entirety. On the contrary, its pulverisation and fragmentation into its basic elements was absolutely necessary to produce painterly contrasts."

Kasimir Malevich

upon the latter's visit to Moscow in 1914. In previous years Malevich, stimulated by western role models, had developed his own Cubist-Futurist style. Following Cézanne's maxim that viewed all objects in nature as spheres, cylinders, and cones, Malevich also reduced the objects in his paintings to simple and strongly contrasting plastic forms. Unlike Picasso and Braque, however, Malevich did not concentrate on grey or brown values in his colouration, instead employing glowing colour contrasts in his compositions. Thereby he found his way to a unique cubist vocabulary of form, as the French painter Fernand Léger had simultaneously formulated it in his contrasting forms.

In the first half of the 1910s, Malevich developed a constantly more reductive compositional style, using austere stereometric forms from which identifiable objects gradually disappeared. At the same time these stereometric volumes gained pictorial independence, so that Malevich began to speak of "realistic cubo-futuristic forms", thereby emphasising the independent qualities of his formal elements, in contrast to the mere depiction of visible nature in traditional painting.

Despite this consistent development, in 1915 Malevich made a radical leap in his artistic production both theoretically and in his paint-

ings, with the execution of the first Suprematist compositions. Suprematism asserts the supremacy of pure form. The black square on a white ground, which the artist first introduced at the exhibition "0.10" (null-ten) in 1915 in Saint Petersburg, took painting to a radical extreme. Malevich later predated his invention of the *Black Square* to the year 1913, relating it to his stage-set design for the opera "Victory over the Sun" by Mikhail Matyushin: "In 1913, in my desperate attempts to free art from the ballast of the concrete world, I fled to the form of the square." Later Malevich repeated the *Black Square* several times, sometimes varying it, sometimes replacing it or combining it with other forms. By superimposing the forms he created optical stratifications as well as perspective space.

With Suprematism Malevich made a decisive step in the development of abstract painting in the twentieth century. Abstraction of the natural world had not just developed into a synthesis of the forms of reality (as in Synthetic Cubism), but also expressed the independent realism of absolute forms without any associative reference to a concrete model. Numerous Russian artists followed Malevich along this path, or developed independent positions of their own out of his

1930 — The first issue of the magazine "Cercle et Carré" appears in Paris
1930 — Second "Surrealist Manifesto" by André Breton 1932 — The Bauhaus in Dessau is disbanded and moves to Berlin

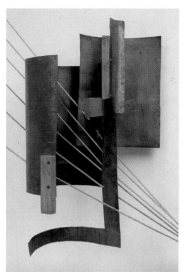

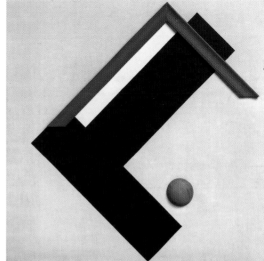

15. WLADIMIR TATLIN

<u>Counter-Relief</u>
1914/15, metal, wood, wire, 118 x 71 cm
The State Hermitage Museum,
St. Petersburg

16. FRIEDRICH VORDEMBERGE-GILDEWART

<u>Komposition Nr. 19</u>
1926, wood, oil on canvas, 80 x 80 cm
Sprengel Museum Hannover, Hanover

15

16

artistic achievements. After the outbreak of war in 1914, El Lissitzky returned from Germany to Moscow. There he completed his studies of architecture in the following year. From 1919 onwards, Lissitzky's *Proun* concept transferred Malevich's geometric compositions to architectural pictorial constructions. At the same time, Vladimir Tatlin went a decisive step further by expanding upon Malevich's Suprematist paintings to develop three-dimensional constructions using industrial materials.

For a short time Suprematism and Constructivism managed to remain the official state art of the 1917 Russian Revolution. Only four years later Vladimir Ilyich Lenin's condemnation of the contemporary arts led to a reversal of this fruitful development. Thus ended one of the few historical epochs in which the prevalent political climate had allied itself with progressive artistic forces. Numerous artists including Kandinsky and El Lissitzky left Moscow for the West, where their ideas were taken up with great interest and enthusiasm not only at the Bauhaus in Weimar and later Dessau, but also in Berlin, Hanover, and Paris, and by the Dutch De Stijl group.

Artist Associations and congresses

The ideals of Suprematism and Russian Constructivism radiated out from Moscow to all of Europe. In the next few years painters, sculptors, and architects with similar ideas came together in all metropolises. The European Constructivists emphasised their internationality more than almost any other artistic movement. The First World War and the revolutionary unrest that followed it had been overcome. For artists a period began during which they renounced feelings of nationalism and made renewed contact with like-minded people and comrades-at-arms in other countries. In many places artists banded together to jointly promote and implement their ideals. Besides the Suprematists around Malevich in Moscow, local groups were also founded such as MA in Budapest, die abstrakten hannover in Germany, De Stijl in the Netherlands, and the Polish group Blok. Many of these artist collectives saw themselves as regional branches of an international movement. The Hanoverians Kurt Schwitters, Friedrich Vordemberge-Gildewart, Carl Buchheister, and Rudolf Jahns not only had a member in Berlin with whom they corresponded – César Domela – but they

1933 — Adolf Hitler declared Chancellor of the Reich
announces the New Deal
1933 — American President Franklin D. Roosevelt
1933 — Closing of the Bauhaus in Berlin

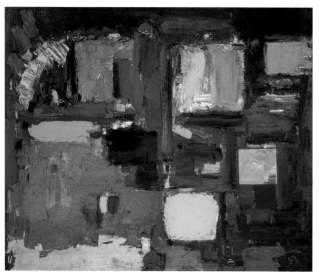

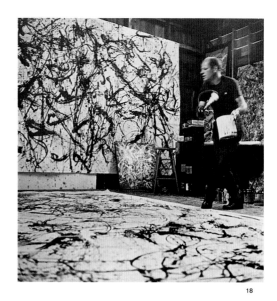

17

18

also worked together under the name "Ortsgruppe Hannover der Internationalen Vereinigung der Expressionisten, Kubisten und Futuristen" (Hanover Chapter of the International Association of Expressionists, Cubists, and Futurists). Finally at the end of the nineteen twenties a majority of the Constructivist artists came together in the rather loose association Cercle et Carré, and the Abstraction-création association founded in 1931.

The great readiness to theorize of many of the artists was noteworthy. Besides their participation in a few large-scale exhibitions, the Constructivists repeatedly organized their own artist congresses. In 1922 the "International Congress of Progressive Artists" took place in Düsseldorf. Some months later they came together again in Weimar. Thereby the Constructivists showed absolutely no fear of encountering the Dadaists or other movements. Theo van Doesburg also acted as a Dadaist under the name I.K. Bonset, and Kurt Schwitters operated his internationally connected, one-man Dadaist movement Merz from the rather tranquil town of Hanover. The artist periodicals published by almost every group were another important medium. These publications served not only to cultivate image and diffuse ideas, but

were also a medium for public relations and advertising. Some of these associations were unusually long-lived, considering that these were avant garde art movements. In 1926 the Dutch De Stijl group was even able to mark the tenth anniversary of their existence in an anniversary edition of their periodical of the same name.

In 1916 the painters Theo van Doesburg, Piet Mondrian, and Bart van der Leck joined forces with the sculptor Georges Vantongerloo and the architect J.J.P. Oud. In the De Stijl movement's manifesto, published only two years later, they ostentatiously demanded: "The artists of today, all over the world, impelled by one and the same consciousness, have taken part on the spiritual plane in the world war against the domination of individualism, of arbitrariness. They therefore sympathize with all who are fighting spiritually or materially for the formation of an international unity in life, art, and culture."

The members of the movement propagated a universal language of form that was intended to be concentrated, clear, and logical. Its colour spectrum was reduced to pure colours and the non-colours, thus yellow, red, and blue, plus black, white, and grey. They applied these to the canvas in unmodulated tones, using strict geo-

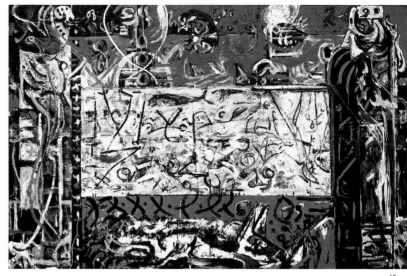

17. HANS HOFMANN
The Ocean
1957, oil on canvas, 152 x 182.5 cm
Private collection

18. HANS NAMUTH
Jackson Pollock painting in his studio on
Long Island, 1950

19. JACKSON POLLOCK
Guardians of the Secret
1943, oil on canvas, 122.8 x 191.3 cm
San Francisco Museum of Modern Art,
Albert M. Bender Collection

19

metric planes and orthogonal lines. Aesthetically they aspired to surpass the narrow confines of their own discipline, and to include all creative areas of life: graphic design, architecture, and the applied arts. This humanist ideal found practical application above all in the teachings of the Dessau Bauhaus after 1925. Appropriate workshops were available there, and the famous training centre with its prominent teachers also maintained the necessary contacts with producers. To this day, so-called Bauhaus design has retained its aesthetic leading role in disciplines such as architecture and product design.

Abstraction as a universal Language of Art

The historic caesura occasioned by the Second World War rearranged the map of contemporary art. The new political powers would also climb to be the leading nations in the field of art. The great nation of France in particular lost its political and cultural supremacy. The United States, on the other hand, advanced to the position of the world's leading art nation. The old art capital of Paris was displaced by the young metropolis of New York. The town attained this position for itself not just on its own, however; instead this conquest was initiated by the impulses coming from Europe. Many leading artists, but also some younger ones, had to leave their European homelands to flee to the USA to escape persecution by the Nazis and the terror of the war. Josef Albers, Max Ernst, Hans Hofmann, Marcel Duchamp, and Piet Mondrian provided pioneering stimuli to a young generation of American artists. Eager to learn, the New York painters quickly developed independent artistic positions of their own, and an unbroken self-confidence.

When in 1958 the New York Museum of Modern Art sent an extensive exhibition of current American painting through eight European cities under the title "A New American Painting" – an exhibition that included series by Jackson Pollock, Willem de Kooning, Franz Kline, and Mark Rothko – these presentations seemed like a statement of claim to artistic hegemony. No European painter had an adequate answer to the unhesitatingly powerful painterly gestures and monumentality of many of the canvases. While the French École de Paris cultivated a largely aestheticizing *peinture*, the young American

1937 — The exhibition "Degenerate Art", organized by the Nazi Party to show works of banned artists, begins its tour in Munich
1939 — Diplomatic recognition of Franco's nation state by the world powers marks the end of the Spanish Civil War

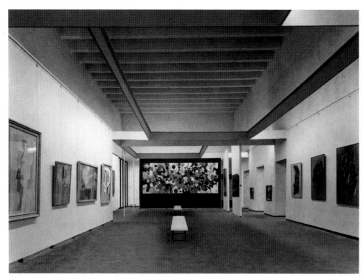

20.
documenta II, 1959

20

painters broke with all artistic conventions. Free gestural abstraction asserted itself as a symbolic expression of the free individual spirit following the war's millions of anonymous deaths. It was also this situation that made the catchphrase "abstraction as a universal language" popular.

Acknowledgement of Autonomous western Art

In Germany the development of abstract modernism had been interrupted by the Nazi condemnation of any progressive artistic developments as "degenerate art". German artists were forced into either real- or inner emigration. After the political liberation of 1945, early abstraction in West Germany also had moral arguments against realistic painting traditions on its side. Establishing the documenta exhibitions in Kassel, less than fifty kilometres from the inter-German border that separated the two political blocs during the Cold War, was also a political acknowledgement of autonomous western art, as opposed to the restrictive Social Realism officially sanctioned by Mos-

cow. After the first exhibition had been staged in the summer of 1955 as a revision of Classical Modernism, documenta II then presented itself four years later as the seismograph of a free, Western art world. In the preface to the accompanying exhibition catalogue Werner Haftmann wrote: "The general direction that has become apparent in the last fifteen years is thus quite clear. While so much artistic thinking from Expressive Realism, through Surrealism, all the way to Concrete Art, lay in the years immediately following the war, all of these individual artistic directions finally resulted – and one can name 1950 as an approximate reference year – in abstract art."

The catchphrase that abstraction was a universal language of art, however, lead to a belief in a coherence and homogeneity that had never existed in the abstract painting of the nineteen fifties. The great number of different conceptions is more indicative of the coexistence of independent and contradictory artistic approaches than to a unified school of abstraction. The following list, as extensive as it may seem, still gives only a selection of stylistic descriptions of the abstract painting of the time: Art Informel, Abstract Expressionism, Lyric Abstraction, L'Art autre, Emotional Non-Figurative, Tachism, and Action Paint-

1939 — Beginning of the Second World War with the German attack on Poland
1941 — Germany attacks the Soviet Union 1941 — Japanese attack on Pearl Harbor; the United States declare war on Japan

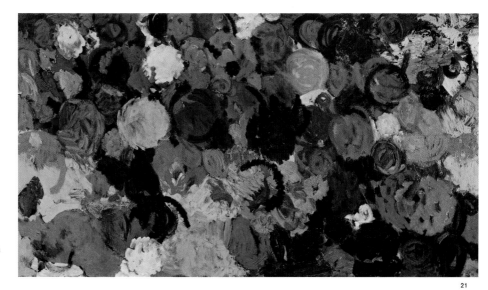

21. ERNST WILHELM NAY
Blauflut (Flood of Blue)
1960, oil on canvas, 190 x 340 cm
Museum Ludwig, Stiftung Peill,
Cologne

ing. Some of these concepts actually identify national schools such as the École de Paris or the New York School. While it was largely agreed that West German painting could be spoken of as Art Informel, the New York artists found themselves only very unsatisfactorily characterized by a term such as Abstract Expressionism. Other formulations described the artists' stylistic approaches. Action Painting stands for dynamic artistic expression based on bodily movement, employed as spontaneously and with as little control as possible. This title embraces such work as the German Karl Otto Götz's paintings, the Drippings of American painter Jackson Pollock, and the spectacular Action Paintings of the French artist Georges Mathieu, who could boast of being able to finish his works in less than ten seconds.

In the Western section of a Germany divided after 1945, the artists first had to win their artistic freedom and develop an independent position through great effort. Only a few of them, such as Ernst Wilhelm Nay, had been able to continue developing their artistic work, in a state of inner emigration, even during the Nazi years. In 1937 that painter, 35 years old at the time, had been the youngest artist pilloried by the Munich "Degenerate Art" exhibition. The first large survey shown at the

end of the nineteen forties was still carried out as an all-German event. Realistic and abstract positions were represented as equals in these exhibitions. Yet the established representatives of Expressionism and New Objectivity from the pre-war years were unable to reclaim their earlier positions. While the one had lost expressive power in its paintings, the other lacked analytical severity in its motifs. The progressive young abstract painters were primarily seeking a way out of their artistic isolation. They banded together into several regional groups.

Emil Schumacher participated as early as 1948 in the group junger westen. Willi Baumeister was a member of ZEN 49, which formed one year later. Karl Otto Götz exhibited with the Frankfurt group Quadriga. Only Ernst Wilhelm Nay refrained from joining any group. He established himself quickly, and in the nineteen fifties he occupied an unchallenged and unique position among abstract painters in the German Federal Republic. At the same time German artists were also seeking international inspiration and contacts, and thereby followed tradition in orienting themselves towards Paris.

As early as 1953 the critic John Anthony Thwaites, then living in Germany, could state: "The victory of Abstraction is so complete

1944 — "D-Day", landing of allied troops in Normandy 1945 — End of the Second World War in Europe
1945 — Atom bomb dropped on the Japanese cities of Hiroshima and Nagasaki

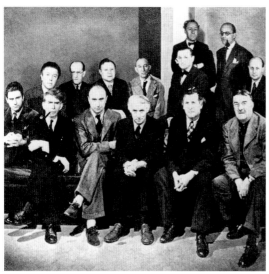 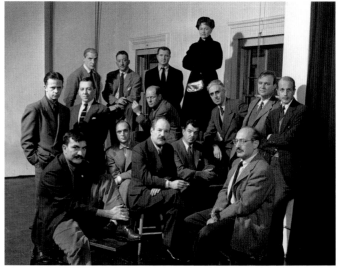

22 23

"Art history is a bowl of alphabet soup; the artist reaches in and spoons out what letters he wants."

Willem de Kooning

that it is difficult to find a young artist of quality who is not dependent upon it. The young artists and their young audience alike regard abstract art as their natural element." Artistic events taking place in America at the same time were still barely noticed. Even when the second documenta opened in 1959, the exhibition's curators still had to rely on the support of their colleagues from New York's Museum of Modern Art in order to present in Kassel a somewhat representative view of the American art scene.

L'art Autre – Another Kind of Art

After the liberation of Paris in 1944 an unbroken tradition of modernism continued to exist in France, although it had been driven to inner emigration during the years of occupation. Pablo Picasso and Henri Matisse had been the two outstanding representatives of this tradition during the nineteen fifties, but they were also competitors. The younger representatives of abstract painting, including Georges Mathieu, and the two German immigrants Hans Hartung and Wols,

came together for the first time in 1948 in the Parisian gallery of Colette Allendy, in the exhibition "H. W.P. S.M. T.B.", a name derived from the names of the participating artists. The painter and literati Michel Tapié later coined a label for their works, "l'art autre" or the other art, a painting style that did not want to be connected with classical modernism, but sought an independent new beginning. The works of this so-called École de Paris, which Pierre Soulages and Jean Bazaine also belonged to, but which never saw itself as a programmatic school, were characterized by non-objective spatiality, and lyrical colour effects.

In contrast to this were the representatives of the artist group Cobra, whose paintings had developed out of a Nordic painting tradition. Its members came from the three capital cities COpenhagen, BRussels, and Amsterdam, and the first letters of these cities' names were used for the group's name. However with only a few exceptions these artists, who included the Dutchman Karel Appel, the Belgian Pierre Alechinsky, and the Dane Asger Jorn, always clung to figuration. Influences from graffiti, children's drawings, and primitive art influenced their works, which they captured on canvas using unusually drastic motifs and with fantastic creative power.

--

1945 — Founding of the United Nations (UN) with 51 members

1948 — Proclamation of the independent state of Israel 1949 — Founding of NATO

--

22. GEORGE PLATT LYNES

<u>Participants in the exhibition "Artists in Exile" at the</u>
<u>Pierre Matisse Gallery in New York, March 1942</u>
From left to right, front row: Matta, Ossip Zadkine,
Yves Tanguy, Max Ernst, Marc Chagall, Fernand
Léger; back row: André Breton, Piet Mondrian,
André Masson, Amédée Ozenfant, Jacques Lipchitz,
Eugène Berman; standing: Pavel Tchelitchew, Kurt
Seligmann

23. NINA LEEN

<u>Group photograph of American Artists 1951:</u>
From left to right:
seated: Theodoros Stamos, Jimmy Ernst,
Barnett Newman, James Brooks, Mark Rothko;
first row standing: Richard Pousette-Dart,
William Baziotes, Jackson Pollock, Clyfford Still,
Robert Motherwell, Bradley Walker Tomlin;
second row standing: Willem de Kooning, Adolphe
Gottlieb, Ad Reinhardt, Hedda Sterne

24. ROBERT RAUSCHENBERG

<u>Erased de Kooning Drawing</u>
1953, traces of ink and chalk on paper,
in passe-partout with gilded frame
64.1 x 55.2 cm
San Francisco Museum of Modern Art,
Gift of Phyllis Wattis

24

New York as the world capital of Art

New York, later to become an art capital, was not yet present on the map of the artistic avant garde during the first half of the twentieth century. Not until the end of the nineteen tens had an internationally connected Dada movement developed quickly in the city, fed primarily by the presence of European immigrants such as Marcel Duchamp and Francis Picabia, and supported by the photographer Man Ray, who though born in Philadelphia had also just returned from Paris. In 1913 the spectacular Armory Show gave the New York audience its first extensive introduction to current artistic developments in Europe. The city's phenomenal rise to the position of undisputed world capital of art in the nineteen fifties to nineteen seventies was one of the consequences of European political developments. The Nazi rule of Germany and the Second World War that began there drove many well-known artists to distant, safe New York.

The presence of European immigrants in the New York art scene, their exhibitions in the galleries there, and their teaching activities in American colleges, exercised an immense influence on young American painters. Two photographs, taken a decade apart, mark this transition from the European art capital of Paris to the young metropolis of New York. In 1942 New York's Pierre Matisse Gallery produced the exhibition "Artists in Exile" and on that occasion brought the participating European artists together for a group portrait: Max Ernst sits in the middle, and around him are grouped André Masson, Roberto Matta, André Breton, Yves Tanguy, Piet Mondrian, Marc Chagall, and Fernand Léger, among others. Most of these artists had participated in the activities of the Parisian Surrealist movement.

Thirty years later Marcel Duchamp, who had fled Europe in 1942, answered an interviewer's question of whether the American avant garde had been born during the Second World War: "Yes, and that is also generally not denied. Breton's influence is undisputed. Naturally the American artists always point out that they themselves had done good things, but do not forget their sources of inspiration in the form of Breton, Masson, Max Ernst, and Dalí, or Matta too." These influences can in fact be seen in the early works of very many American painters who later painted abstractly. Willem de Kooning, Robert Motherwell, Barnett Newman, and above all Jackson Pollock devel-

1949 — Founding of the Federal Republic of Germany and the German Democratic Republic
Peoples Republic of China by Mao Zedong 1949 — Proclamation of the
1955 — In Kassel the first documenta is opened under Arnold Bode

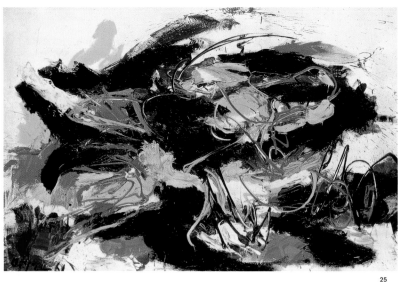

25. KAREL APPEL
<u>Landscape</u>
1961, oil on canvas, 130 x 195 cm
Niedersächsische Landesgalerie, Hanover

25

oped their abstract work from Surrealism and from *écriture automa-tique*, a form of unconscious, uncontrolled writing.

The 1942 photo of the New York exiles stands in contrast to that of a new group in 1951. The shot was taken for an article in the illustrated magazine Life. Grouped around the stately looking Barnett Newman are Jackson Pollock, Mark Rothko, Robert Motherwell, Willem de Kooning, Ad Reinhardt, and Clyfford Still. Jimmy Ernst, the son of the great Surrealist Max Ernst, represented the link to the older European generation.

Yet that the exiles had come together here in the nineteen forties was by no means the sole reason that New York rose to the position of international capital of the artistic avant garde. By their example and with their activities these artists had simply provided the young Americans with the aesthetic impetus. It was a happy combination of various factors that allowed the New York art scene to achieve such domineering significance in the following decade. Besides the influence of European artists in America, the political climate can also be seen as partly responsible. The United States had emerged from the Second World War as the leading nation, both economically and militarily. The feeling of strength, invincibility, and unshakeable self-confidence also transferred itself to the young generation of artists. Unlike their comrades of the same generation in Europe, the painters in New York were not confronted with an artistic tradition in which they saw themselves imprisoned, and against which they could only have rebelled with difficulty.

The abstract painters of the nineteen fifties had produced wonderful artists of note, whose works also developed impressively in the following decades. Jackson Pollock, Willem de Kooning, and Mark Rothko particularly represent that first generation of American artists through whom New York achieved its leading position in contemporary art. Their rank as almost legendary heroes of American painting has never been questioned by the following generations of artists, such as representatives of the much more publicly appealing Pop Art. As a style-setting epoch, however, Art Informel and Abstract Expressionism were only able to exercise their full influence for a short period. Their final breakthrough in 1958 at the World's Fair in Brussels, the Venice Biennale, and particularly at the second documenta the following year, simultaneously formed the high point and the water-

1956 — The exhibition "This is Tomorrow" in the Whitechapel Art Gallery, London, promotes Pop Art 1957 — The USSR
launches the earth's first satellite, Sputnik 1958 — Founding of the European Economic Community (EEC), precursor to the EU

26. BARNETT NEWMAN

<u>Chartres</u>
1969, oil on canvas, 305 x 290 cm
Private collection, New York

"Aesthetics is for artists what ornithology is for birds."

Barnett Newman

shed of these movements. Abstraction's aura very soon attracted innumerable less-gifted imitators, who were quick to copy the compositions of their artistic role models with brush strokes that were as elegant as they were empty. An exhibition such as that in the London Institute of Contemporary Arts in 1957, featuring the artistic effusions of painting chimpanzees, was an especially fitting caricature of abstract painting's proliferation as a decorative element of the everyday world, yet this still did not devalue the aesthetic achievements of abstraction's artistic forerunners.

The conquest of abstraction as a global language had actually begun four years earlier, then still unnoticed by the public. Robert Rauschenberg's work *Erased de Kooning* marked the definite turning point and the assault of the next generation of artists upon the aesthetic canon of their artistic progenitors. In 1953 Rauschenberg asked the then-famous Willem de Kooning for an abstract pencil drawing, which he subsequently erased in weeks of difficult work. Only light traces and damage to the paper's surface remained of the abstract composition. Here, the act of destroying existing values simultaneously marks the onset of a new artistic orientation. Yet ten

more years were to pass before this new reversal of all aesthetic values became impressively visible to the outside world, when in the year 1962 the grand prize for painting was awarded to Robert Rauschenberg at the Venice Biennale.

1959 — First Fluxus action by Nam June Paik in Düsseldorf
Fidel Castro becomes President

1959 — Revolution in Cuba;
1960 — John F. Kennedy elected President of the United States

Daniel-Henry Kahnweiler

Oil on canvas, 101.1 x 73.3 cm

The Art Institute of Chicago, Chicago, Illinois, Gift of Mrs. Gilbert W. Chapman in memory of Charles B. Goodspeed

b. 1881 in Malaga (Spain)
d. 1973 in Mougins (France)

By 1910 Pablo Picasso had reached a first high point of his artistic career. After the blue and pink periods his work underwent a radical formal change around 1907. In Cubism Picasso had found a new stylistic idiom, and he consistently refined it in the years that followed, until it approached the borders of abstraction. In 1910 Picasso was just twenty nine years old, his work was being purchased by international collectors, and in his place of residence alone, Paris, he was working with three art dealers who acquired and exhibited his works.

During this year he made portraits of all of them: the Germans Wilhelm Uhde and Daniel-Henry Kahnweiler, and the French Ambroise Vollard. This artistic undertaking made it seem as though Picasso were negotiating his business relations with these gallery owners during their portrait sittings. Despite formal similarities, each depiction still has individual features; Picasso included his relationship with the model in each of the three portraits.

The *Daniel-Henry Kahnweiler* portrait is the most radical of the three. Here Picasso took Cubism's process of abstraction the farthest. The abstraction also reveals something of the distance between the two men, who were never more than business partners. The figure of Kahnweiler can hardly be made out within the thick network of angular lines. Only some details emerge from the prismatic structure, like realistic anchors. The wavy hair, narrow nose, and thin little moustache manifest the model's individuality. Kahnweiler's crossed hands are suggested at the picture's lower edge.

The painting is one of the high points of Picasso's first Cubist phase, known as the analytical phase. The cubic forms, which were still solid in compositions such as *Demoiselles d'Avignon* produced three years earlier, had meanwhile dissipated. The painting's foreground and background were now interwoven into a unified spatial structure. Picasso reduced the lively colour contrasts to a modulated spectrum of browns and greys. Form dominates colour in this way in all three of the Cubist portraits of his art dealers. Picasso in fact worked as if engaged in scientific analysis. And like in a scientific experiment, he subdued all secondary aspects and concentrated his investigation completely on developing a new stylistic idiom. Thereby he did not simplify his model's portrayal, but rather took apart what he saw to create a complex network of elementary, open forms. These forms always have solid contour lines on only one or two sides, fading away gradually on their other edges. Thereby the elements overlap and penetrate one another to form a complex rhythmic structure. Entire sections of the paintings, such as the images' central zones, offer viewers no comprehensible motif and appear completely abstract.

Picasso was never an art theorist. He was always a visually oriented person who derived his motifs and formal vocabulary solely from his immediate surroundings, and never actually stepped beyond those boundaries into the non-representational.

> **"There is no abstract art. You must always start with something. Afterwards you can remove all traces of reality. There's no danger then, anyway, because the idea of the object will have left an indelible mark."**
>
> **Pablo Picasso**

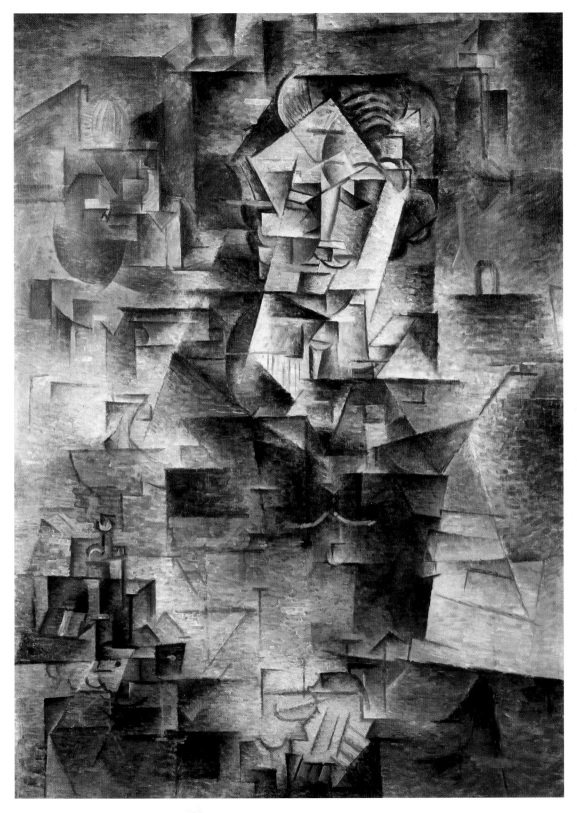

First Abstract watercolour

Watercolour, 50 x 65 cm
Private collection, Paris

b. 1866 in Moscow (Russia)
d. 1944 in Neuilly-sur-Seine
(France)

Wassily Kandinsky did not entitle this work *First Abstract Watercolour* until a while after he had created it, and only later did he date it 1910. At the time Kandinsky was already forty three years old, but he was just at the beginning of his artistic development. Kandinsky had completed his studies of law when he decided, at the age of thirty, to go to Munich to study art. His early work was influenced primarily by the French Impressionists and the folk art of his Russian homeland. In 1910, even before the first exhibition by the artist collective Der Blaue Reiter (The Blue Rider), Kandinsky produced the manuscript for his theoretical treatise "Über das Geistige in der Kunst" (Concerning the Spiritual in Art), which he could not publish until two years later. In that book Kandinsky formulated his ideas about an autonomous painting style that would not be tied to having to describe objects. In the paintings he made in the years that followed one can very clearly follow the artist's laborious path into abstraction: from his so-called impressions, through his improvisations, to his free compositions.

The *First Abstract Watercolour* seems like a courageous anticipation by the artist of these later compositions of form and colour. As became apparent a few years ago, however, the watercolour was by no means created in 1910, but only three years later. Kandinsky antedated it to the time he wrote his treatise "Concerning the Spiritual in Art". Such manipulations are not unusual in art, generally serving to preserve claims of being the first. In this regard, Kandinsky would likely have been concerned with proving his theoretical ideas by way of a contemporaneous artistic example. Yet the work was also intended to confirm his assertion that he had been the inventor of the first abstract artwork.

Notwithstanding discussions about the year the watercolour was created, the work is unusually dramatic and unique, even for a work from 1913. While the artist's large-format works of the same year still contain sketchy indications of his preferred motifs such as a horse and rider, mountain peaks, and church towers, the watercolour is indeed free of any associations with objects. Only in one of the work's lower corners could one suspect the back of a female nude. The colours on the pictorial surface, however, operate completely independently. They are distributed across the entire format, but form no compact structures. There is a correspondence between the transparency of the watercolours and the forms standing freely on the white surface. The work's black ink drawing and its colourful watercolour painting move independently of each other. Here the colour does not fill out any contours. At various points concentrations of abstract colour combined with drawing arise, but without creating a composition. The distribution of pictorial elements respects no up or down. The improvised, spontaneous character of the watercolour stands out. The dynamism with which Kandinsky applied the paint remains visible in his results. The work seems to have been transposed into a whirlpool of colour and lines. Even when compared to other contemporaneously created watercolours, this aspect of instability and disquiet gives the work its unique quality.

Concerning the Spiritual in Art, 1912,
cover

First simultaneous Disk

Oil on canvas, Ø 135 cm
Collection of Mr. and Mrs. Burton G. Tremaine, Meriden, Connecticut

b. 1885 in Paris (France)
d. 1941 in Montpellier

Robert Delaunay developed his work under the influence of Cubism and Italian Futurism. Orphism, the stylistic term coined by Guillaume Apollinaire inspired by the Greek singer Orpheus, emphasizes the synaesthetic, harmonious character of colour in Orphist compositions. Compared to cubist works by artists such as Pablo Picasso, Delaunay began around 1910 to give his prismatically resolved forms an additional colour quality. His colours continually gained more significance of their own, and in regards to these paintings Apollinaire spoke enthusiastically of a "peinture pure", or pure style of painting, which depended solely on the expressive power of colour.

As a preliminary stage of his completely non-objective *First Simultaneous Disk* of 1913/14, he had produced a group of works a few months earlier incorporating circular forms based on a sun motif. Delaunay had exposed himself directly to the sun's colour and light effects, and then transferred these experiences into painting. The artist spent the summer of 1913 together with his wife, the artist Sonia Delaunay-Terk, in Louveciennes. There he produced certain colour sensations in himself by looking directly into the glistening sunlight, and then attempting to capture directly on canvas the afterimages that appeared when he closed his eyes. The results were compositions displaying a rhythmic whirlpool of colour becoming ever lighter towards the painting's centre, in colours that finally dissolve into a white that outshines everything else.

In *First Simultaneous Disk* Delaunay takes this development one step further by applying a system to both the pictorial composition and colour composition. He divided the round canvas into concentrically organized circles, each of which he divided horizontally and vertically into four semi-circular segments. The colour composition followed a colour theory model: The principle of simultaneous colour contrasts Delaunay employed goes back to the colour circle developed by Michel Eugène Chevreul in 1839. Chevreul organized its colours into complementary contrasts, such as red to green (the secondary colour mixed from blue and yellow), or blue to orange (the secondary colour created from red and yellow). He distinguished warm from cold colours, and the harmonies of similar colour tones from the contrasts of disparate colour values. Delaunay recognized that simultaneously perceiving a pair of adjacent colours could amplify their intensity.

After Delaunay had taken his paintings' abstraction process as far as pure non-objectivism, and he could thus no longer rely on the natural world for his colour compositions, he found himself faced with the challenge of how to arrange the colours on the surface if he didn't want an arbitrary distribution. In 1917 he complained to his friend Apollinaire: "All this haziness, these Cubists and Futurists, all these self-satisfied aesthetic meditations, this painting of states of mind, these fourth dimensions, which is indeed neither painting nor art." Delaunay was rescued from this dilemma by Chevreul's colour theories, which provided his colour compositions with the long hoped-for liberation from arbitrariness, and lent them a formal framework.

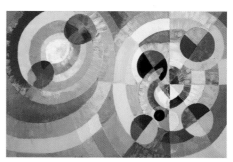

Circular forms, 1930

small composition III

Oil on canvas, 46.5 x 58 cm
Karl Ernst Osthaus Museum, Hagen

**b. 1880 in Munich (Germany)
d. 1916 near Verdun (France)**

In 1912 Franz Marc and Wassily Kandinsky jointhy published the almanac "Der Blaue Reiter" (The Blue Rider). The two artists formed the core of the Munich artist collective of the same name, which also included Alexej von Jawlensky, Gabriele Münter, and Marianne von Werefkin. Marc was the only one among them who would follow Kandinsky along the path to abstract painting. The latter's theoretical writings and paintings were an important influence for Marc. He was also strongly inspired by a visit to the Futurism exhibition in Cologne in October of 1912. Before summer's end in 1913 Marc had produced some of his most magnificent animal paintings, *Tierschicksale* (Fate of the Animals), and the famous but now lost *Turm der Blauen Pferde* (Tower of Blue Horses). Yet by December 1913 he had already painted his first completely non-representational pictures. Marc no longer gave these works descriptive titles, but labelled them *Small Compositions* because of their format, and gave them sequential numbers. He created *Small Composition III* at around the turn of the year 1913/14.

In *Small Composition III* the forms, which had previously been linked to the figures of animals and objects, gained their pictorial freedom. A blossom form in the lower centre of the picture, architecture in the rising orange form, and green treetops at the picture's upper edge perhaps still allow one to surmise the work's representational models. Conspicuous is the clear distinction from Kandinsky's abstract stylistic idiom. Marc developed his compositions from the Futurist repertoire of forms in his last animal paintings. *Small Composition III* is made up of compact spheres and cuboids that become increasingly transparent at their borders. This results in the individual elements being wedged into each other. "Everything is truly connected with everything

else", Marc recognized early on. In his paintings he was interested in the intimacy of expression, which he also wanted viewers to be able to experience: and not just in naturalistic depictions, such as in his earlier portrayals of animals, but above all through the stylistic idiom itself. As early as February 1911 Marc wrote enthusiastically to his wife: "There is no 'object' and no 'colour' in art, but only 'expression'!"

Where "colour" was concerned, Marc was mistaken, for his *Small Composition III* comes alive precisely due to its colouration. Powerful primary colours and pure mixtures of them dominate the composition. The elementary forms set the compact pictorial structure into motion. As was already the case in the work of his Munich comrade Kandinsky, Marc's colourful forms are by no means autonomous, but always communicate expression and transmit particular emotional states. Marc, who in his earlier works contrasts the imperfection of humans with the purity of animals, made his ideas more radical in the abstract compositions. Ultimately, it was only in free compositions no longer bound to a natural model that he was able to experience this primitiveness and the purity of creation he had always sought. Marc's early death in 1916 in the Battle of Verdun brought a sudden end to these very promising developments.

"But he often already said to me at that time that the others prize his animal pictures, but that he himself hoped one day to get over them and surmount them. At the moment 'he still needed the animal' but 'the people will really be surprised about what I serve them up one day'."

Maria Marc

Black square

Oil on canvas, 79.6 x 79.5 cm
The State Tretyakov Gallery, Moscow

b. 1878 in Kiev (Russia)
d. 1935 in Leningrad

At the Russian Futurists' last exhibition "0.10" (null-ten), which took place in 1915 in St. Petersburg, Kasimir Malevich presented thirty seven new paintings that he labelled Suprematist compositions. Compared with his previous, so-called Cubo-Futurist works, these works revealed a radical reduction in his formal vocabulary. His paintings shocked visitors to the Dobychina Gallery, and Malevich provoked an artistic scandal.

Black Square was the central work in his installation. It was the simplest composition, and was already accentuated by being hung higher than the other works. Malevich positioned the canvas across a corner and directly below the ceiling, which in Orthodox Russian homes is a place usually reserved for Christian icons. For Malevich, *Black Square* was a modern icon to replace traditional ones. "Modernism", the artist recognized, "can scarcely adhere to the trinity of antiquity, because life today is square." *Four-cornered Figure* was the name Malevich himself originally selected for the *Black Square*.

The painting's canvas is square, although the black quadrilateral delineated within it is slightly out of square. Its contours and black surface also reveal distinctive marks. Malevich did not reject the tradition of painting which his composition was also heir to. One can clearly make out the gestural brush strokes of the paint application, and the black is applied by no means as evenly as one might expect, given the radical aspirations formulated by the work. Because he applied the paint in several layers the surface is also broken up in numerous places, which reinforces the composition's painterly character. Malevich later painted other versions in various formats, and their surfaces seem more perfect, but thereby also less painterly.

Malevich precisely specified the size of the square on the picture's surface. He consciously avoided filling the entire format with the quadrilateral, instead leaving a white border. Otherwise the painting would have become a pictorial form, an object, and this would have completely contradicted his painterly intentions. Thus the black square placed in the picture's centre creates a proportional balance with its white passe-partout. The black four-sided figure appears neither as a dark hole in the light-coloured surface, nor does the bright border function simply as a frame for the black square.

Malevich's Suprematist compositions of the year 1915 were the first painterly works completely free of any representational link. Instead they lay claim to a realism of their own. Malevich himself backslid from these radical aspirations, however, by entitling a somewhat smaller red square of the same year *Painterly Realism of a Peasant Woman in Two Dimensions*.

"The picture's realism consists in the simultaneous demands made by the three great pictorial conditions: the lines, the forms and the colours."

Kasimir Malevich

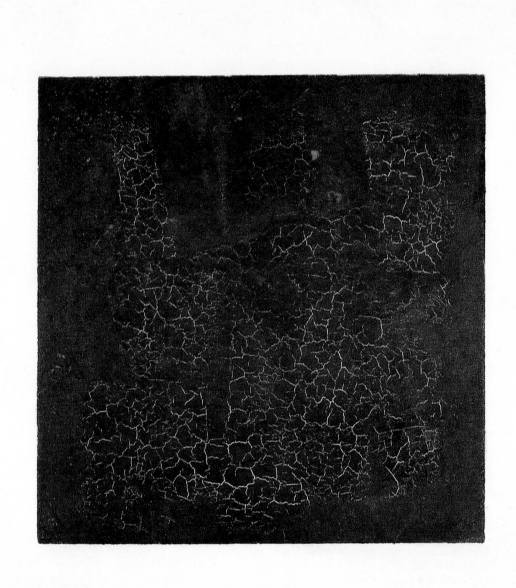

suprematism

Oil on canvas, 44.5 x 35.5 cm
Stedelijk Museum, Amsterdam

With the composition *Suprematism* of the year 1915, Kasimir Malevich translated the monolithic *Black Square* into a dynamic construction of open, conjoined elements. Thereby the coloured cubic planes and black bar-shaped forms maintain a surprising equilibrium. For although the intersections of the planes suggest a perspectival staggering of the forms, all pictorial elements still move on a single level, against a spatially indistinct white surface.

With regards to *Black Square*, Malevich once described the surrounding white space as "white infinity." As an indeterminate space within which the painting's events take place, it also forms the field of action for all other Suprematist compositions. Malevich was fascinated by developments in the still nascent technology of aviation and the conquest of the air. About his pictures' light-coloured ground he said at the time: "The expanse of unpainted white canvas cloth directly produces a strong feeling of space in our consciousness. I feel as if transported into an undersea wilderness, where one can feel the moment of the universe's creation all around." He had already encountered this enthusiasm for technological progress and the dynamics of modern cities among the Italian Futurists.

Malevich entitled another work shown in St. Petersburg *Airplane in Flight*. It consists of thirteen coloured squares, arranged diagonally across the surface. Some Suprematist compositions are indeed reminiscent of the filigree wings of that era's biplanes. The painting *Suprematism* is characterized by similar dynamics and the forms seem to float. Elements aligned with the top of the picture and concentrated in its upper half establish the painting's dynamic character.

For Malevich the decision to construct this composition using four-sided planes exclusively was programmatic. All of them have clear colouration, and some are extremely long, dynamic forms. Some surfaces overlap one another, but without creating perspectival spatiality. Clearly visible in this piece are the characteristics of Malevich's conception of space, as opposed to that in the somewhat later works by El Lissitzky. While all elements exist within a flat space here, Lissitzky's constructions coalesce into architectural structures.

Suprematism marked the first time that painting gave up its function as an instrument of depiction, becoming itself an autonomous component of our reality. The realism in Malevich's painting is the realism of coloured quadrilaterals.

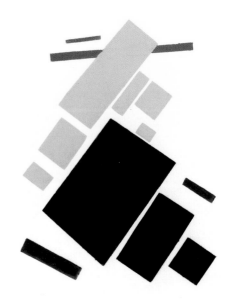

Airplane in Flight, 1915

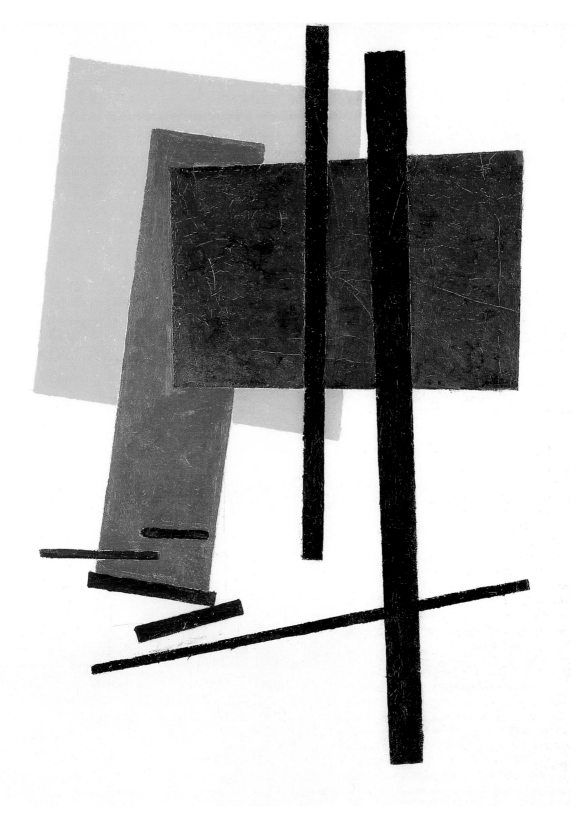

collage Arranged According to the Laws of chance

Collage, 48.6 x 34.6 cm
The Museum of Modern Art, New York, New York

**b. 1887 in Strasbourg
(then part of Germany)
d. 1966 in Basel (Switzerland)**

At the outbreak of the First World War Hans (Jean) Arp was studying at the renowned Académie Julian in Paris. As a so-called enemy alien Arp settled in neutral Switzerland, where he joined the Zurich Dada movement. Like many of his Dadaist companions Arp was doubly gifted, being just as talented and recognized as a man of letters as he was as a fine artist. After Hugo Ball founded the Cabaret Voltaire, Arp participated in the famous Dadaist soirées. The Zurich Dada group was an anti-political, anarchist movement. They agitated against the European governments' policy of war, and formulated their revulsion against unthinking submission to authority, and uncritical nationalism. Their tools were the literary Cabaret, buffoonery, sarcasm, and provocation. In this they also employed their artworks, which they often produced simply for short-term shock value.

In this regard Arp's attitude differed significantly from that of his Dadaist comrades Hugo Ball, Tristan Tzara, and Marcel Janco. His works were directed against the bourgeois artistic tradition. Yet Arp never called the artistic aspirations of his own works into question. Through his programmatic cooperation with other artists and the integration of chance into his creative process, Arp tried to significantly expand what art could be, and how it could be made.

Even the title of the small-format *Collage Arranged According to the Laws of Chance* refers to the way it was created, and to the use of chance as a design principle, even though chance was only a substructure in this type of artistic work. For this piece, produced in Zurich around 1917, Arp cut rough squares from paper of twelve different colours, thereby consciously avoiding any exact right angles. He then dropped the scraps of paper onto the cardboard support. Arp only used the arrangement thus produced, however, as a starting point for further interventions. In a second step, Arp pushed the coloured elements back and forth on the light brown surface until he found a final composition. Finally he grouped the dark squares in a dance-like arrangement around a lighter quadrilateral in the upper centre. Thereby the surfaces never overlap, but they repeatedly touch one another at their corners. Thus the *Collage Arranged According to the Laws of Chance* was by no means created, as the title might suggest to viewers, by following a truly random principle. It would instead be more accurate to speak of an organizing, random element in Arp's work, where artistic design and the principle of chance come together in a counterbalancing process.

Within the tradition of Zurich Dada agitation, Arp's chance collages are conceived as a means of disrupting bourgeois art traditions. Arp himself had always preferred to emphasise their positive energy, and attributed an ethical quality to them.

> "These works are constructs made up of lines, surfaces, forms, and colours that try to go beyond the human and attain the infinite and the eternal. They reject our egotism."
>
> **Hans Arp**

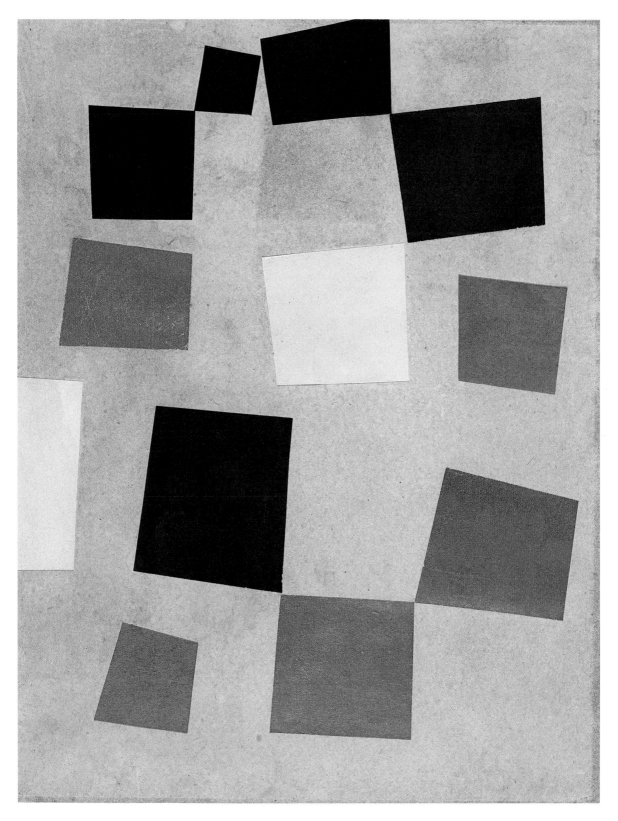

Proun R. V. N. 2

Mixed-media on canvas, 99 x 99 cm
Sprengel Museum Hannover, Hanover

b. 1890 in Pochinok (Russia)
d. 1941 in Moscow

The Russian Constructivist El Lissitzky created the painting *Proun R. V. N. 2* in 1923 in Hanover, where he had an exhibition in the Kestner Gesellschaft at the beginning of that year. Following the exhibition Lissitzky received an offer to stay in Hanover and move into an empty studio owned by the Kestner Gesellschaft. The Hanover Merz artist Kurt Schwitters became an important contact person and congenial partner for him. Lissitzky designed the handbill for Schwitters' Merz Matinée, and in 1924 they designed an issue of the Merz magazine together. The painting's unusual title is a tribute to Schwitters and to the city in which the piece was created. R. V. N. refers to Schwitters' transcription of the city name Hanover into RE VON NAH, which Lissitzky reduced to its first letters R. V. N. At the end of 1923 Lissitzky had to leave the city again, because a serious lung illness forced him to undergo an extended stay at a sanatorium in Switzerland.

Between 1920 and 1925 Lissitzky named all of his compositions *Proun*, a word he himself had derived from the Russian phrase "Proekt utverzdenija novogo" (project for the affirmation of the new). For him they were, as he formulated it in 1921, "stations on our path towards new forms". A Proun is therefore a work of transition. Inspired by Lissitzky's interest in Kasimir Malevich's Suprematism, they follow a course of development from picture to architecture; Lissitzky had studied architecture in Darmstadt from 1909 to 1914. In fact, some early *Proun* titles still refer expressly to this architectural connection. In 1920, for example, he created the works *The City (Proun 1A)* and *The Bridge (Proun 1E)*.

From its square format alone the painting *Proun R. V. N. 2* of 1923 can be seen as a programmatic work. Lissitzky avoided using the signal-like colour effects of red planes, selecting only muted brown, grey, and black tones for his composition. The motif combines broad flat areas and extremely three-dimensional forms. In the centre stands a light circular area, which he shifted just slightly away from the middle of the picture. This aspect of movement and uncertainty is stabilized once again by the four square areas placed in the painting's corners. They touch and sometimes overlap the light-coloured circle. Three narrow architectural forms with clear but by no means uniform edges of light and shadow float in front of the circular plane. Each of these objects appears to be lit by its own light source. Despite this, none of the forms throws a shadow on any of the other objects or on the light-coloured disk in the background. This also makes the position of individual elements in the space confusing.

Lissitzky's *Proun* works abandoned the illusionistic space of traditional painting. He reversed the idea of a picture being a view out a window into perspective space. In the *Proun* works the composition unfolds against a back wall. The individual components occupy the space between pictorial surface and viewer, and so appear to conquer real space. Compared with the traditional conception of painting Lissitzky thus formulated an idea that was radically new, and one in which the *Proun* works were to be understood as a draft version for future architectural ideals.

"we saw that the surface of the canvas ceases to be a picture and turns into a structure round which we must circle, looking at it from all sides, peering down from above, investigating from below."

El Lissitzky

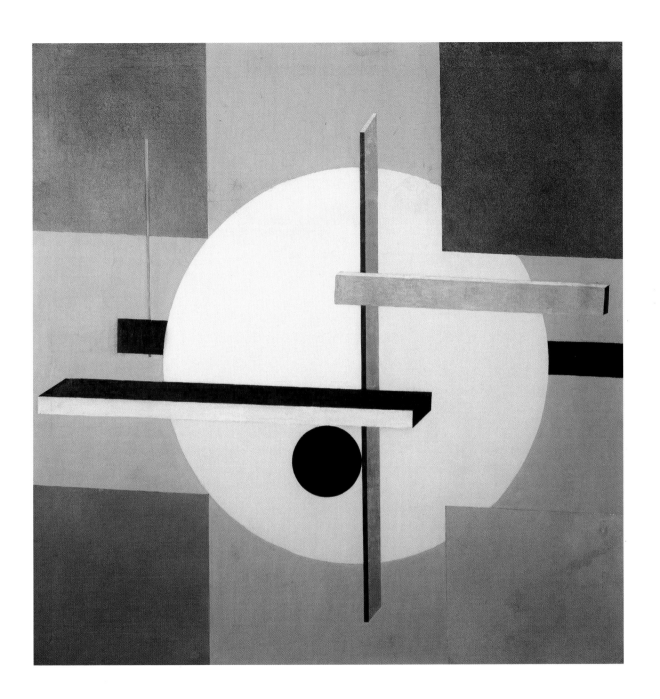

contra composition v

Oil on canvas, 100 x 100 cm
Stedelijk Museum, Amsterdam

b. 1883 in Utrecht (Netherlands)
d. 1931 in Davos (Switzerland)

Theo van Doesburg, born Christian Emil Marie Küpper, presented himself as a Dadaist under the pseudonym I. K. Bonset. Van Doesburg met Piet Mondrian in 1916; one year later they were the two leading minds of the De Stijl movement in Holland. In the first issue of the magazine of the same name, the group presented two central demands: "The truly modern – meaning conscious – artist has a double task. Firstly: to produce the purely composed artwork; secondly: to make the audience receptive to the beauty of the pure visual arts." No other member of the De Stijl group identified as much with these demands as Van Doesburg.

He was committed to extending De Stijl thought beyond the narrow boundaries of painting, architecture, and the applied arts. Following the First World War he made numerous international contacts, organized exhibitions, formulated manifestos, and held lectures and teaching events. Van Doesburg designed architectural models and planned interiors. It was above all at the Bauhaus in Wiemar that he found his ideals of integrated artistic design in all areas of life, and of interdisciplinary education realized. His hopes of a position at the institution, however, were never fulfilled. Instead Van Doesburg organized an independent De Stijl course for Bauhaus students in the summer of 1922.

Van Doesburg neglected his own painting during that period, and concentrated entirely on developing his draft designs and projects, and on theoretically formulating De Stijl. Not until 1924 did he once again produce a small group of paintings, which he entitled *Contra Compositions* and which occupied a counter-position to his earlier compositions of 1920. His previous compositions had consisted of harmonic arrangements of square and rectangular flat forms. The pictorial formats were characterized by a large square, accompanied by several other planes. He applied the paint smoothly without visible brush strokes. Unlike Mondrian, van Doesburg allowed himself a richly graduated colour spectrum.

With the *Contra Compositions* of 1924, Van Doesburg took a decisive step away from the harmony and stasis of his earlier works. By tipping the position of his quadrilaterals by forty five degrees, he created a previously unknown openness and dynamic. None of his squares or rectangles are completely drawn in the new works. They all extend beyond the format's boundaries into an imaginary, universal space. Viewers only see fragments of all of the forms. Optically, the diagonals set the block-like forms in motion. Mondrian would later only indicate these boundary transgressions. In this compositional dynamisation and the break with strict horizontals and verticals, Mondrian saw such an affront by Van Doesburg against De Stijl's original ideals, that in 1925 he left the group in protest.

"once the means of expression are liberated from all characteristics they are on their way towards the real goal of art: to create a universal language."

Theo van Doesburg

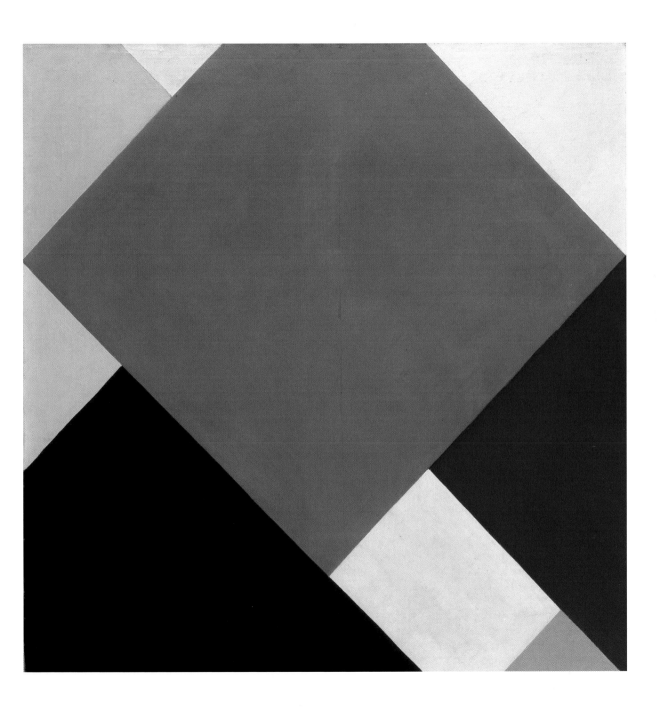

Merz 1924, First Relief with cross and sphere

Oil, cardboard, and plastic panel on wood, 69.1 x 34.4 x 9.3 cm
Kurt und Ernst Schwitters Stiftung, Hanover

**b. 1887 in Hanover (Germany)
d. 1948 in Ambleside (Great Britain)**

The Hanover artist Kurt Schwitters was close friends with Hans Arp, just as he was with Theo van Doesburg. Both were among those representatives of the international art scene who did not advocate any strictly dogmatic, anti-bourgeois or anti-art positions. Schwitters always remained artistically independent, and in 1919 he founded his one-man art movement MERZ. The name came from one of his assemblages of that year, called the *Merzbild*, which would also lend its name to further activities later: to Merz poetry, Merz architecture, and Merz theatre. Schwitters was artistically multitalented, and was a gifted communicator and networker. From Hanover, which was then a provincial capital, he developed connections during the nineteen twenties to all international art centres.

His distanced relationship to the politically active Dada movement in Berlin and to their mouthpiece Richard Huelsenbeck earned him the friendship of Arp and van Doesburg. While his collages, assembled using garbage from the street, may have been extremely provocative to some viewers, Schwitters always strove to create aesthetically balanced artistic compositions. He himself spoke of his aspirations towards a pure art.

Around 1923 Schwitters' work went through a conspicious transformation. After the end of Dadaism, Schwitters grew closer to the Bauhaus and to the Dutch De Stijl movement. He then only used the garbage and newspaper fragments in a very trenchant manner. From then on Schwitters used a much clearer pictorial language. The Merz painting of 1924, *First Relief with Cross and Sphere*, however, is an extreme work even within this group, while also being an outstanding example of Schwitters' adoption of a Constructivist formal vocabulary. For several months at the beginning of 1923 Schwitters went with Van Doesburg and that artist's wife Nelly on a "Holland Campaign", which included Dadaist lecture evenings. For Schwitters, this trip was particularly noteworthy as his initiating encounter with the theories of the Dutch De Stijl movement.

These experiences found their artistic expression in the 1924 relief. The composition is dominated by right angles and reduced colouration. Schwitters restricted his colours to black, white, shades of grey, and a signal-like red. Between narrow horizontal lines, vertical lines, and broad planes he created a harmonic structure, which he then broke up again with two central objects. In the work's middle section Schwitters focussed on two elements that lend the composition a disconcerting tension. Within the double cross on the left side is a beige area bearing an austere drawing of a pair of stereometric cuboids. To the right of this is a red hemisphere. Illusionistic space encounters real plasticity in these two elements. These are the two artistic concepts that not only the De Stijl movement, but also Russian Constructivism was repeatedly concerned with in both practice and theory. El Lissitzky, one of its main representatives, had lived in Hanover some months before this relief was created, and in 1924 he had worked together closely with Schwitters.

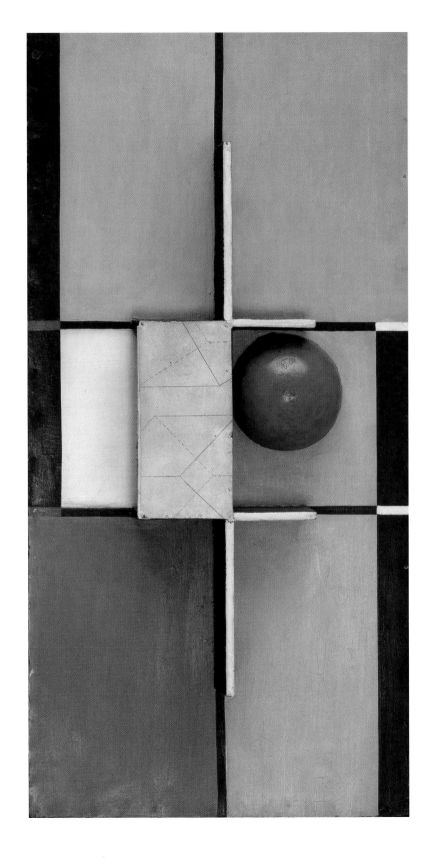

ın the ฿lue

Oil on cardboard, 80 x 110 cm
K 20 – Kunstsammlung Nordrhein-Westfalen, Düsseldorf

In the Blue was produced in 1925, the year the Bauhaus had to move from Weimar to Dessau. Wassily Kandinsky had taught at the college since 1922. Among his colleagues were Lyonel Feininger and Paul Klee, with whom he would later share one of the Masters' Houses. In the text "Punkt und Linie zur Fläche" (Point and Line to Plane), which appeared in 1926, he further developed his early theory from "Über das Geistige in der Kunst" (Concerning the Spiritual in Art). The mid-sized painting *In the Blue* differed considerably from Kandinsky's works of the early nineteen tens. Here the free brushwork gave way to strict geometric forms. A flat paint application replaced modulated colours. Instead of representational allusions to riders, architecture, and landscape, one finds the elementary forms of circles, triangles, and quadrilaterals. Symbolic design replaces narrative elements.

As in many of Kandinsky's works of the nineteen twenties, the composition of the painting *In the Blue* also includes a circular form at its centre, although it is by no means the dominant element here. The geometric forms are arranged against a blue background. They form a complex structure of discs, circle segments, triangles, and quadrilaterals, and are superimposed upon one another in delicate nuances. Kandinsky had encountered examples of such transparency in the glass workshop at the Bauhaus, and like Paul Klee he had integrated it into his painting. On the canvas' surface the forms constitute two complex groups. The large structure at the picture's centre, all elements of which appear to be attached to a dark triangular form, is accompanied by a smaller shape in the painting's lower left corner. Around these two metaforms is a greenish coloration that delicately fades to the blue of the background. This makes the forms appear lit from behind, or surrounded by a radiant corona of colour. This painting has repeatedly provoked comparison of its composition with a cosmic order.

In 1930 Kandinsky confessed in a letter: "In the past few years when I have so often and passionately used circles, for example, then the reason (or cause) is not the circle's 'geometric' form or geometric characteristics, but rather my strong sense of the inner power of circles in their innumerable variations; I love circles today as I earlier, for example, loved horses." In his treatise "Concerning the Spiritual in Art" Kandinsky attributed very specific characteristics to all combinations of forms and colours.

Thus he not only combined forms and colours into an autonomous composition in his paintings, but additionally overlaid them with inner values, moods, and tensions. Kandinsky assigned a specific characteristic to every form and every colour: circles symbolized perfection, yellow stood for earthliness and expressed solidity. Different combinations of form and colour would give a red circle, a blue square, or a red triangle their respective individual expressive qualities. They could balance or augment one another, such as by placing a sharp colour within a pointed form. The artist spoke of the colour yellow in a triangle as an example of this. Yet one does not have to have read Kandinsky's writings to be moved by his abstract compositions. They communicate not just theoretically, but also and particularly intuitively – and that is their special quality.

"necessity creates the form."

Wassily Kandinsky

vertical-нorizontal composition

Oil on canvas, 110 x 65 cm
Museo Civico Castello, Visconti

b. 1889 in Davos (Switzerland)
d. 1943 in Zurich

In 1915 in Zurich, Sophie Taeuber met her future husband Hans Arp, with whom she participated in the Dadaist performances at the Cabaret Voltaire. She designed the costumes and appeared as a dancer.

In 1916 Taeuber-Arp took a position as a teacher for textile technologists at the arts college in Zurich, and earned enough from her job to support the young couple. During this period she developed her abstract geometric style, using a clear, planar formal vocabulary that was ideal for transfer to her textile works.

For a long time the idea circulated in art history that Taeuber-Arp had derived her artistic style from Arp's abstract works and transferred it to the applied field of textile design. In fact, however, it appears to have been exactly the opposite. The conditions for the production of textile materials required a reduced, flat style of depiction. Combining technical constraints with an abstract formal vocabulary, Taeuber-Arp developed a radical contemporary stylistic idiom, from which Arp also profited. Arp himself once confirmed this as a source of inspiration for his work: "The clear calm of Sophie Taeuber's vertical and horizontal compositions influenced the baroque diagonal dynamics of my abstract 'compositions'."

Her severe, static pictorial compositions were a reaction to the Expressionist stylistic idiom, but at the same time they were also an affront to the anti-aesthetic formal vocabulary of their Dadaist compatriots. *Vertical-Horizontal Composition* was created in 1927/28, thus almost a decade after the Dadaist revolution in Zurich, and it is one of Taeuber-Arp's most complex and mature compositions. Particularly impressive about the work is its harmonious overall effect, but with a simultaneous feeling of imbalance among the individual pictorial ele-

ments. The layout of the small quadrilaterals spreads across the pictorial surface like a grid placed behind the composition. The larger rectangles are consistantly made up of a number of these basic quadrilaterals. This allowed Taeuber-Arp to achieve a harmoniously arranged structure despite large discrepancies between individual elements. The quadrilaterals, which are identical in format, and related in tonal value, contrast with the larger rectangles. The composition adheres to an architectural structure. The light yellow area breaks through the colourful tones of the remaining pictorial elements, yet despite this it does not appear as a factor disturbing the composition. If one compares Taeuber-Arp's work with Piet Mondrian's compositions of the same period, then in both artists' work one finds a similar concentration on a horizontal-vertical pictorial structure. Taeuber-Arp's compositions, however, are much more richly orchestrated. She permits delicate graduations between base colours, evoking a lyrical mood in this manner. Yet viewers also recognize the decorative origins of the compositions. The ability to transfer such motifs executed in oil on canvas

Composition Aubette, ca. 1927

into the medium of patterned cloth or carpet seems to have been considered right from the start in Taeuber-Arp's works. In 1929 she gave up her position at the art college in Zurich and moved with Arp into a house they had designed themselves in Meudon near Paris, where they lived next door to Theo van Doesburg.

Highroads and Byroads, 1929/90

Oil on stretched canvas, 83.7 x 67.5 cm
Museum Ludwig, Cologne

**b. 1879 in Münchenbuchsee
near Bern (Switzerland)
d. 1940 in Muralto/Locarno**

This work's title, *High-roads and Byroads 1929/90*, also stands like a motto over Paul Klee's biography. When he painted this work in 1929, he lived in Dessau and taught at the Bauhaus there. Four years earlier the school had moved to this city from Weimar. Klee's life led him from Bern to Munich to Weimar, where he began teaching at the Bauhaus in 1921, and then to Dessau. He repeatedly undertook longer trips, the most famous being a trip to Tunisia in 1914 with August Macke and Louis Moilliet. "Color has taken possession of me; no longer do I have to chase after it", he noted in his diary during this stay in North Africa.

Early during 1929 also found Klee far from Dessau; for one month he travelled through Egypt. The painting *Highroads and Byroads*, which he created after this journey, appears completely permeated by his impressions of it. Klee's pictures are never pure abstractions; the title, if nothing else, returns them to a figurative or representational order. Klee was a masterful inventor of condensed signs and codes; he used individual symbols and concrete signs, arrows, letters, and numbers to direct his viewers' attention.

At more that eighty centimetres in height, the painting is unusually large among Klee's works. Despite this it possesses the sensitivity and delicacy of his intimate drawings. At first glance the composition appears abstract. Across the painting's entire surface lies a filigree network of fine hand-drawn lines, which divide the motif into a grid of narrow rectangles. Yellow, bluish, and greenish colours fill these planes and divide the format into a variable structure of rhythmically organized fields. The picture's entire pale surface has the appearance of being backlit. The transparent colours are reminiscent of Egypt's glistening light. The staggered, initially abstract rectangles evoke associations with a landscape of cultivated fields. The horizontal blue stripes at the upper border are thus reminiscent of a river, or of waves rolling onto a beach. Down the centre of the picture runs a series of fields, diminishing in perspective towards the top. This must be the highway mentioned in the title. Appended to it on the left and right are the mentioned byways. They are irregular, sometimes broad, sometimes narrow, and wind off towards the horizon. The colouration of these byways is more intense than that of the broad main path; the byways are more varied, more enthralling, and more exciting.

This initially abstract composition by Klee proves at second glance to be an Egyptian landscape, and upon closer inspection to be a metaphor for various styles of living. In that year Klee had celebrated his fiftieth birthday, and indeed the painting can also be read as an interim appraisal of his life. It describes the possible alternative paths he could take through life, starting from his life experiences until then. In a letter of September 13, 1929 to his wife Lily, Klee complained: "The Bauhaus no longer upsets me, but people demand things from me that are only partly fruitful. This is and will continue to be disagreeable. Nobody can do anything about it except me, and I do not find the courage to leave." In the following year, however, Klee did pursue a new path, and accepted an appointment as professor of painting at the art academy in Düsseldorf. Yet when he finally moved with his family to Düsseldorf for May 1, 1933, the Nazis had already dismissed him from his teaching position.

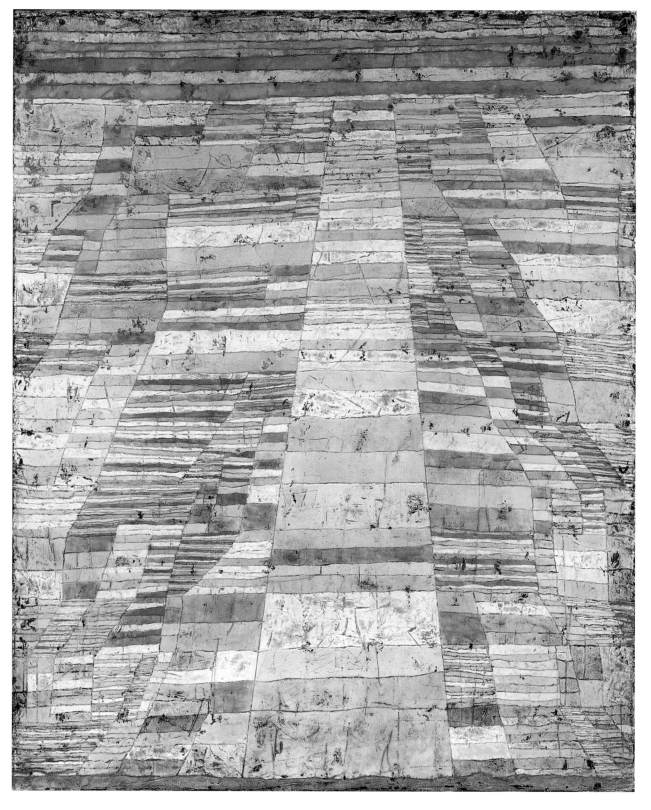

composition NO. II. composition with Blue and Red

Oil on canvas, 40.3 x 32.1 cm
The Museum of Modern Art, New York, New York, Gift of Philip Johnson

**b. 1872 in Amersfoort
(Netherlands)
d. 1944 in New York/NY (USA)**

Piet Mondrian's painting *Composition No. II. Composition with Blue and Red* is one of the classic stylistic innovations of this series. Mondrian had already developed this work's compositional concept in 1921 while living in Paris. After several years during which he hardly painted, it was there that he developed the compositions of austere black horizontal and vertical lines, filling the spaces between them with red, blue, and yellow fields of colour. Although these pictures reveal no natural associations at all and present themselves as pure compositions of strictly ordered lines and planes, a look back at Mondrian's early work shows the consistency with which he had developed these motifs step-by-step from his earlier depictions of trees and architectural vistas. In the 1929 structure of black lines the tree's dark branches are still present as an idea. Mondrian had continually reduced the natural model until only individual horizontal and vertical lines remained. They give this composition of coloured planes its firm architectural stability.

Through his abstract paintings Mondrian was seeking a new classical ideal of harmony and beauty. Thereby their final execution was preceded by a long series of draft versions and initial attempts. The result is a harmonious balance between the positioning and boundaries of the coloured areas, both in the tension between them as well as in their relationship to the two accompanying white areas. Thereby at the end of the nineteen twenties Mondrian was working towards compositions that were continually more reductive. *Composition No. II. Composition with Blue and Red* of the year 1929 consists of just five fields, only two of which are coloured. In this work the artist completely left out the primary colour yellow. A large white rectangle occupies the centre instead. The red and blue colour fields

have been shifted to the upper edges. This gives the picture its lightness and appears to work against gravity.

Unlike in Mondrian's earlier works, none of the planes of this pictorial composition are enclosed on all four sides by black lines. The main effect of this is to give an impression that the coloured planes extend beyond the format into imaginary space. Mondrian integrated an element in the composition, however, to counterbalance the black bars extending outwards from the painting. The vertical line does not touch the painting's upper edge, but instead ends shortly before it within the red colour field. This compositional device for the black lines is found in almost all his works of those years. Mondrian uses this to expressly emphasize the composition's subordination to the proportions of the canvas.

Mondrian had developed his abstract compositions from a natural model. Ultimately they are no longer representations, but unique artistic creations; they formulate an ideal harmonic counterworld to the experienced creatureliness of nature.

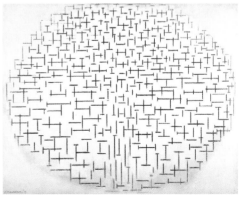

Composition 10 in Black-and-White, 1915

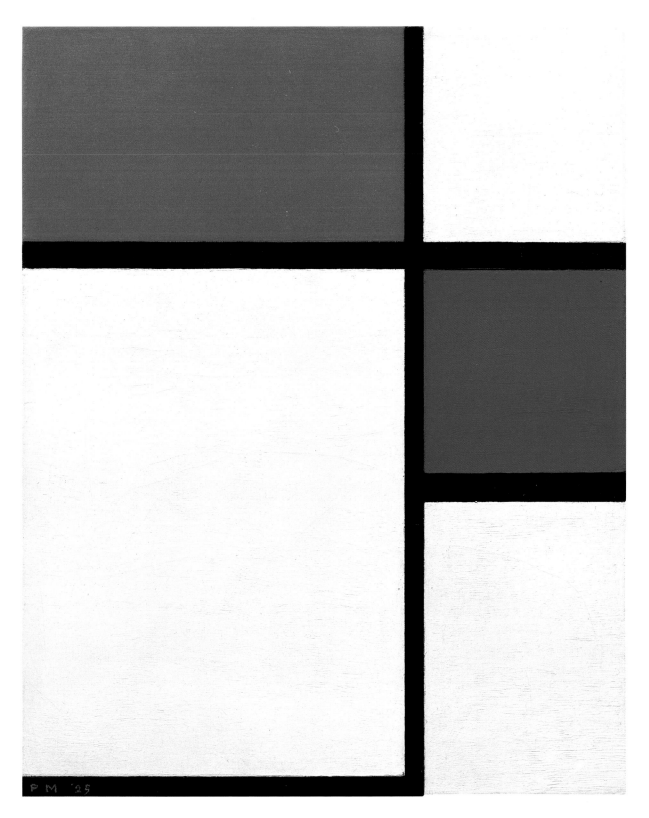

unistic composition NO. 8

Oil on canvas, 60 x 36 cm
Museum Sztuki, Lodz

b. 1893 in Minsk
(then part of Russia)
d. 1952 in Lodz (Poland)

Before Wladyslaw Strzeminski came to Poland in 1922 with his wife, the sculptress Katarzyna Kobro, he had already proven himself as a proponent of Suprematism in his native Russia. In the early nineteen twenties he stood in close contact in Moscow and Vitebsk with the Suprematist movement's founder Kasimir Malevich, as well as with Vladimir Tatlin. Malevich became his inspiration, stimulating Strzeminski's own theories of Unism that he first formulated in Poland.

In 1924 Strzeminski and Kobro were among the founding members of the Warsaw artist group Blok which published the avant-garde magazine of the same name. It was here that Strzeminski's first theoretical formulations on Unism appeared of which he developed and made more specific in 1928 in the book "Unism in Painting." In this book Strzeminski proclaimed a challenging pictorial concept: "It is high time to revise the concept of the abundance form and other related concepts. Even a superficial analysis of this concept should be enough to show that with the abundance of form we are identifying precisely the thing that destroys the picture's unity, it divides, and instead of an organic unity it produces a mechanical conglomerate of parts that cannot be united. It is now not contrast that should be the criteria for pictorial form, but its unity and the means of creating this unity." In fact it would be several years before Strzeminski succeeded in translating this radical postulation into a corollary style of painting.

In Unism Strzeminski replaced the variety of forms with a uniform surface, and supplanted composition with a rhythmic structure. In this manner he succeeded in producing painterly works for which contemporary art found no response until decades later, such as in Frank Stella's black stripe paintings. Strzeminski's Unism of the early nineteen thirties is distinguished by its non-relational compositions without centre or border zones, and with no order or hierarchical structure. Instead, structural elements of continually repeated fragments spread completely across their surfaces. These produce an even grid that alludes to the space beyond the boundaries of the painting support. At the same time Strzeminski reduced his earlier paintings' colouration to a single light value.

The radical work *Unistic Composition No. 8* is an outstanding example of his aspirations, initially formulated only theoretically. The painterly structure covers the work's surface like a finely woven net. Thereby it is by no means sterile or mechanical, but always individually composed. The colouration, just as lively, shimmers on the surface in delicate yellow tones. Unlike previously, however, the colour appears to have been drawn out of the painting here, and to dissolve in a bright backlight. In 1932, the year this work was created, Strzeminski was honoured with the art prize of the city of Łódź. Because of how radical his Unistic compositions were, the choice was violently attacked in the press. Indeed, the courageous artistic step he took at the time has never received the recognition it deserves.

"The movement of the eye, the nature of the line drawn by vision in movement appears as one of the major elements of the new visual content."

Wladyslaw Strzeminski

Broadway Boogie-woogie

Oil on canvas, 127 x 127 cm
The Museum of Modern Art, New York, New York

At the end of 1938 Piet Mondrian, fearing the threat of war, left Paris and moved to London. Two years later the war caught up to him there. In the face of German air raids on the British capital, Mondrian travelled further to New York. The metropolis made an overpowering impression on him. He was fascinated by the enormous skyscrapers, pulsating street life, and overwhelming neon signs. These things also influenced his art, and Mondrian's pictorial vocabulary once again underwent a renewal. While his earlier compositions of the nineteen twenties might have led one to suspect links with the naturalistic model of the tree, his new paintings became concretizations of New York street life.

Mondrian was able to retain the strict horizontal and vertical grid of his older works in the new works as well. Now, however, he linked this to the straight-lined, ruler-drawn grid of the numbered streets of his new Manhattan home. The title of the painting, *Broadway Boogie-Woogie*, even refers specifically to one of the wide avenues, Broadway: the street of pleasures, cinemas, cabarets, and musicals. The composition's musical component is addressed in the second part of the title. The boogie-woogie was a type of piano music that arose from Jazz, and which produced a uniquely American dance craze. Mondrian was not just an enthusiastic Jazz fan, but also a passionate dancer. The image of New York streets as depicted in the painting seems filled with the rhythm of this music and the movement of dancers.

This motif of 1942/43 was completely freed from the stiff compositional structures of his 1929 *Composition No. II. Composition with Blue and Red*. In the later work Mondrian replaced the black bars with glowing yellow lines, within which he placed red, blue, and gray quadrilaterals at rhythmic intervals. Between the bars he left the light-coloured, primed canvas unpainted. Only in a few places do blocky coloured inserts join some of the lines to one another. They seem like wide blocks of buildings between lines of streets laid out at right angles.

In these years Mondrian discovered a new technique to aid him in composing his paintings. He used coloured adhesive tape, which allowed him to repeatedly check his compositions, vary their rhythms, and slowly develop their final forms. Some of these collaged first drafts of his painted pictures have even been preserved, and provide an informative insight into his working process.

Broadway Boogie-Woogie was later surpassed by the painting *Victory Boogie-Woogie*, which remained unfinished upon Mondrian's death in 1944. Yet even its intermediate stage already shows the composition's increased dynamism. Mondrian balanced the square canvas on one unstable corner. The grid pattern of the stripes, previously emphasized clearly, are condensed here into a coloured pattern. The victory cry in the picture's title may be related just as much to the war's approaching end as it was to his surpassing his earlier, more regimented compositions, and successfully infusing the pictorial surface with musical rhythm.

"The emotion of beauty is always obscured by the appearance of the object. Therefore the object must be eliminated from the picture."

Piet Mondrian

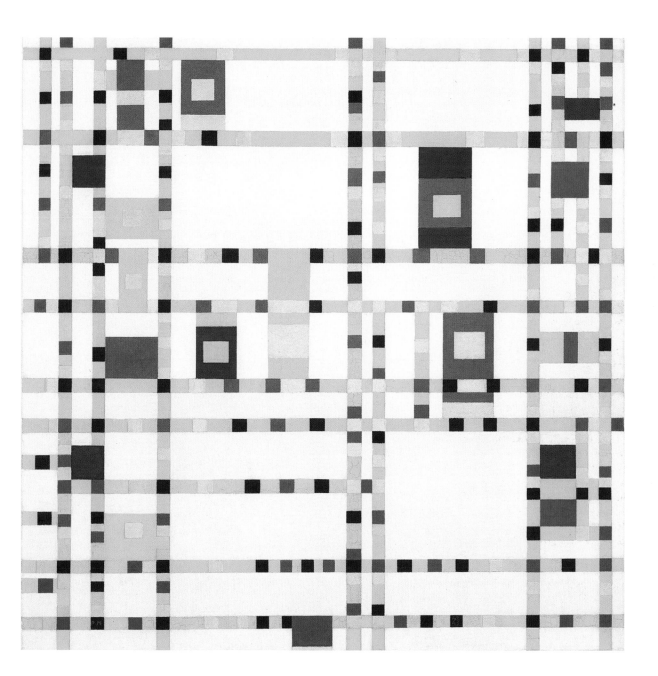

cathedral

Enamel and aluminium paint on canvas, 181.6 x 89 cm
Dallas Museum of Art, Dallas, Texas, Gift of Mr. and Mrs. Bernard J. Reis

b. 1912 in Cody/WY (USA)
d. 1956 in East Hampton,
Long Island/NY

Jackson Pollock's early works were influenced by Pablo Picasso and Joan Miró, by European Surrealists, and by the art of North American Indians. He was thirty one years old when Peggy Guggenheim – the well-known patron of the arts who was then married to painter Max Ernst – first exhibited his work in her New York gallery Art of This Century. Pollock began making his so-called Dripping paintings in 1947. *Cathedral* is one of the earliest examples from this group of works. He had been able to adopt the drip technique from Ernst. In the early nineteen forties Ernst created a series of paintings employing the 'oscillation' process he had invented. For this he laid the canvas flat on the floor and let a paint-filled bucket, in the bottom of which he had punched a hole, circle above it. The bucket's movement left a mechanically circling trail of paint on the picture's surface.

Pollock came up with his own unique method of applying this technique, and called it dripping. Liberating the canvas from the wall's surface and working on it on the floor were the first decisive steps. The canvases were also generally not yet mounted on a stretcher frame during this stage of the work in his studio. Pollock once emphasized that he needed the hard resistance of the floor for his technique. This was also true in a very practical sense, for he quite literally moved within the often monumental formats, walking across his canvases. In the finished paintings one can occasionally still find prints from the soles of his shoes. Pollock applied the paint to the canvas without actually touching the surface, by allowing the paint to dribble off a stick or brush, from which also came the term drippings and his nickname "Jack the Dripper." Besides traditional oil paints, Pollock also used industrial enamels and aluminium paint equally, which underlines his painting style's radically new approach. Pollock became the central figure in a reorientation of American painting after the end of the Second World War, and for its worldwide recognition in the nineteen fifties.

During the actual painting process Pollock moved around the canvas like a dancer. At this stage of the work in the studio his compositions had no upward or downward orientation. He treated both sides and every part of the canvas with equal intensity. Only after he had completed the composition did Pollock decide its orientation for presentation on a wall. His compositions were a direct expression of his actual movement which wandered like a seismographic trace across the surface of the canvas. More than most of his New York contemporaries, he liberated his paintings from the constraints of traditional composition and created a non-hierarchical all-over structure that referred to the space beyond the boundaries of the painting's support. Thereby the formats were often so large that viewers in the museum, like the artist in the studio, felt included in the composition.

Cathedral already clearly exhibits the tightly interwoven coloured structure of the enamel paint preferred by Pollock at the time. At the beginning of the nineteen-fifties his paint application became freer, and his formats became more monumental.

"I work inside out, like nature."

Jackson Pollock

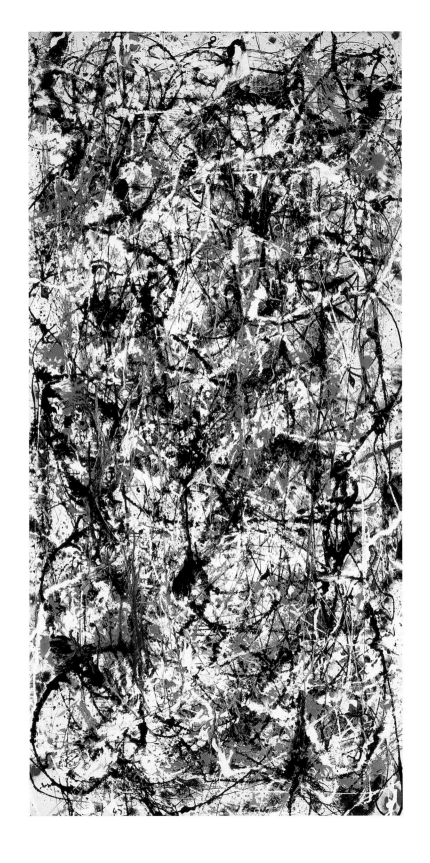

тне вlue рhantom

Oil on canvas, 73 x 60 cm
Museum Ludwig, Cologne

b. 1913 in Berlin (Germany)
d. 1951 in Paris (France)

Alfred Otto Wolfgang Schulze was twenty four years old when he shortened his name to Wols. Wolfgang Schulze had found this combination of initials in a telegram and adopted it. By then the artist was no longer living in Germany, which he had left for France in 1932. In the later nineteen thirties Wols cultivated close contacts in the Paris Surrealist movement. This influence can be clearly seen in his works on paper. Most prominent among his sources of inspiration were Yves Tanguy, Max Ernst, and Salvador Dalí. Thus his early work went through similar development and a comparable emancipation process as did that of his American painter colleagues Mark Rothko and Robert Motherwell. When in 1952 the French man of letters Michel Tapié coined the term "l'art autre", which also fit the work of Wols, the latter had already died of food poisoning at only thirty eight years of age.

Wols had long preferred to work on paper, and thereby was always happy to employ various techniques combined or contrasted with one another. He often applied the bold strokes of black ink on top of painterly techniques such as watercolour, opaque white, and sometimes oil paint. His compositions, often constructed around a central form, thereby evoke associations with violent intrusion. They seem like wounds and injuries to the picture's surface.

Wols first began painting on canvas in 1946. He produced *The Blue Phantom* five years later, in the year of his death. The title and association with a dark shadowy figure seem to continue some of the artist's earlier Surrealist motifs, but simultaneously allow the work to become a *memento mori*, a premonition of death. A background of bright red and yellow lies behind the dark figure, giving it a brightly glowing aura, and making it faintly reminiscent of an apparition of Christ. An impression like this of a phantom-like apparition, however, is not typical of Wols' painting. The way he applied the paint expressly emphasized its materiality and presence, and the aggressive brush strokes made it come to life on the canvas. With the back end of the paint brush Wols repeatedly scratched open the surface, leaving nervous marks in the motif. While in a remark among his aphorisms he named Paul Cézanne as one of his inspirations, in his paintings Wols nonetheless distanced himself from Cézanne's lucid landscapes for the most part: "The painting can have a relationship to nature, like a Bach fugue has to Christ, for it is not an imitation, but an analogous creation."

Yellow Composition, ca. 1947

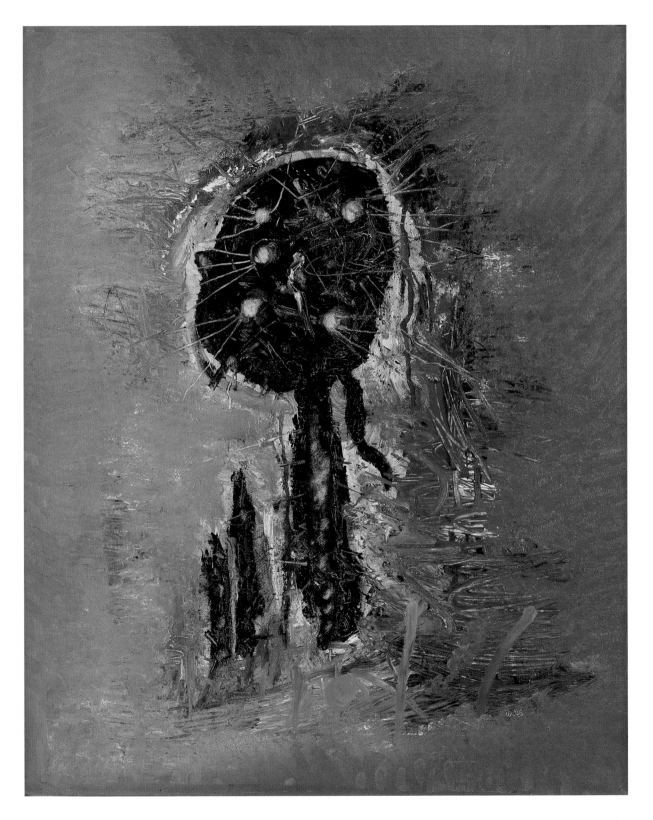

painting of ғeb. 8, 1953

Mixed-media on canvas, 175 x 145 cm
Saarlandmuseum, Moderne Galerie, Saarbrücken

**b. 1914 in Aachen (Germany),
lives in Wolfensaker**

Karl Otto Götz's studies at the art college in his native city of Aachen ended when he was banned from painting in 1933 by the Nazi "Reichskulturkammer" [Reich Chamber of Culture]. In the years that followed he was only able to create his art in secret. Despite this he continued to develop his work, and in 1939 he produced his first abstract paintings. Götz's motifs from the nineteen forties were influenced by the Surrealists, by Max Ernst, Richard Oelze, and Willi Baumeister, with whom he had personal contact from 1942 onward. His works of the first post-war years were populated with abstract figures and surreal characters. In 1949 he was the only German painter to participate in the COBRA group's important exhibition in the Stedelijk Museum in Amsterdam. Together with Bernard Schultze, Heinz Kreutz, and Otto Greis, he exhibited in Frankfurt am Main at the Zimmergalerie Franck in December 1952. On the very evening of the opening the artists founded the group Quadriga.

By this time, the early nineteen fifties, Götz had fully formed his pictorial vocabulary. The surrealist repertoire of figures had disappeared from his works, while the automatism of painterly gesture, influenced by Surrealism, remained. Besides the Frenchman Georges Mathieu, Götz was one of the few European painters who could apply the American label 'action painting' to their work. The quick flourish of a paint-soaked brush on the canvas and his partial relinquishment of conscious aesthetic control characterized his painting process, which Götz described as follows: "Speed was a necessary ingredient for me, to keep the degree of conscious control to a minimum. Speed also gave rise to shifting forms, passages, and textures (veils and splashes), which I could not have achieved with slower, more controlled painting."

The compositions did not have any preset orientation. During the painting process the canvas lay on the floor. The artist walked around it and attacked it from all sides. Thereby Götz generally applied the paint with broad brushes and brooms, using quick movements. The composition traces these movements, allowing them to remain visible to viewers. The brush pushed forward in one direction, made a quick turn, and then ran out towards the far corner of the painting. These dynamic oscillations took place against a light-coloured background, whereby colours and forms seemed to burst apart as if exploding.

If one compares several of the artist's works, certain patterns become apparent. Despite the painterly automatism in applying the paint, Götz practiced and varied certain gestures. As its title, the painting under discussion here bears a laconic statement of its creation date, *Painting of Feb. 8, 1953*. Three days earlier he painted another work (*Painting of Feb. 5, 1953*), which was significantly smaller in size, but similar in style. Both compositions create diagonal cross forms, in which the energy of the movement of paint flows towards each painting's four corners. Götz managed not to let uncontrolled automatism end in artistic chaos, but instead to direct it along compositional channels.

Painting of Feb. 5, 1953

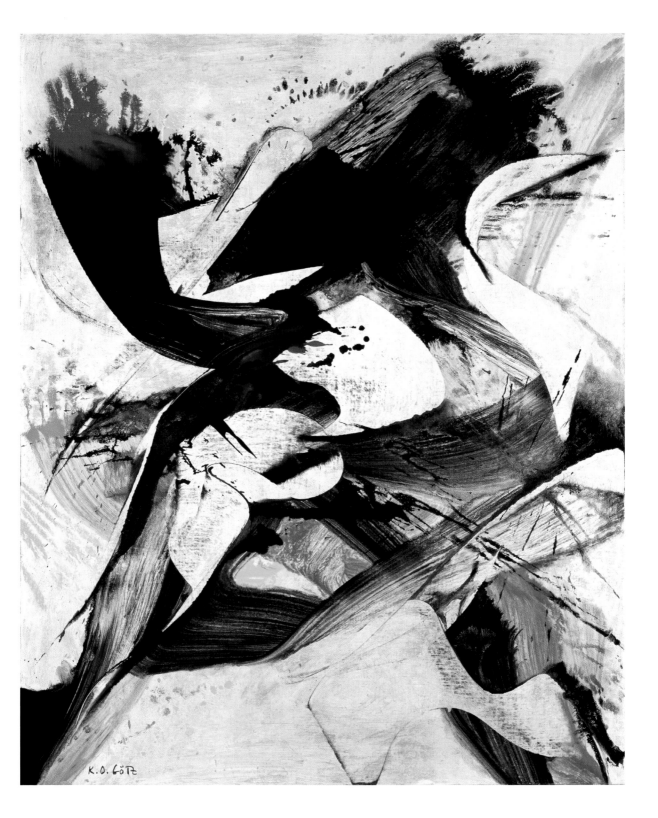

Elegy to the spanish Republic no. 34

Oil on canvas, 203.2 x 254 cm
Albright-Knox Art Gallery, Buffalo, New York, Gift of Seymour H. Knox, Jr., 1957

b. 1915 in Aberdeen/WA (USA)
d. 1991 in Provincetown/MA

Robert Motherwell studied philosophy before he began to paint at the age of twenty five. As an art theorist and painter he was one of the most important intermediaries between the European Surrealists and young American artists. Until well into the nineteen seventies he regularly held lectureships as an art historian at two New York schools, Columbia University and Hunter College. In 1944 Motherwell had his first exhibition in the legendary gallery Art of This Century owned by Peggy Guggenheim, who was then married to the Surrealist Max Ernst. He had already met Ernst two years before that. Motherwell created his work based on the model of Surrealist painting, and on that style's *écriture automatique*. Motherwell once said, "The essentially creative principle of contemporary painting I employ is what psychiatrists would call 'free association,' and what the Surrealists, who essentially discovered a systematic use of the principal, called 'psychic automatism'." Due to this automatism his paintings seem like a form of composition created out of the alternating orchestration of free gesture and correcting intervention.

By the end of the nineteen forties he had already begun his series of *Elegies to the Spanish Republic*, and they preoccupied him for more than three decades. He produced more than 250 works in this period. The theme seems inexhaustible for Motherwell; he dealt with it extensively in various media and different formats. *Elegy to the Spanish Republic No. 34* is one of the largest works on this theme. All versions within the series are variations of a similar main motif. Each painting is based on a monumental black form jutting from the painting's upper edge into the picture plane, and made up of alternating vertical and round elements lined up beside one another. This form sits against a colourfully accented background. In this particular piece the form is a rhythm of white and brown bars, into which blue and red planes are mingled. This type of accompanying orchestration of various bright colours is what lends stability to the black megaform in all the paintings.

When Motherwell began the series, the short era of the democratically legitimized Spanish Republic had already been over for more than a decade, defeated by the troops of the fascist general Francisco Franco. Besides Pablo Picasso's epochal composition *Guernica* of 1937, this series by Motherwell is the most important work referring to the events of the Spanish Civil War. The monumental black symbols express the motif of the elegy, or song of lament, and in the series' large formats this can almost be felt physically by viewers. Motherwell denied any motif-related explanations of his theme, but he did emphasize the emotional power of his colours.

> "My 'spanish Elegies' are free associations. Black is death, white is life […]. The 'spanish Elegies' are not 'political', but my insistence that a terrible death happened that should not be forgot. They are as eloquent as I could make them."

Robert Motherwell

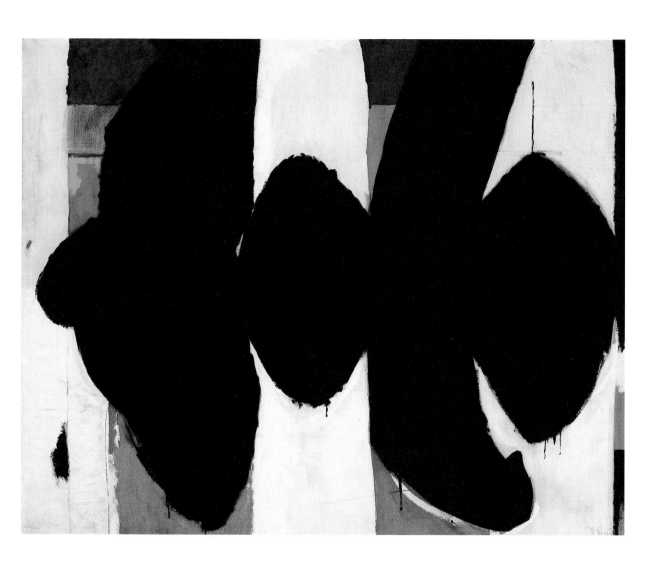

capetians everywhere

Oil on canvas, 295 x 600 cm
Musée national d'art moderne, Centre Georges Pompidou, Paris

**b. 1921 in Boulogne-sur-Mer
(France), lives in Paris**

The term *action painting*, which was actually applied to a few painters of New York's Abstract Expressionist movement, in fact fits no painter better than the French artist Georges Mathieu. This artist began to work as a self-taught painter in 1942 while still studying law and philosophy. His paintings are the product of painting performances, and are spontaneously transcribed notations. The compositions were created primarily during his actions. The largest of these performances took place on May 23, 1956, during the "Night of Poetry" in Paris' Théâtre Sarah Bernhardt. There, before an audience of more than two thousand people, Mathieu painted a four-by-twelve meter canvas within twenty minutes. In 1959 he explained the main principles of his painting in an interview with the German magazine *Das Kunstwerk*: "I believe the speed of the creative act is one of the most important prerequisites of my painting style. In any case I am the first painter to introduce the concept of speed into occidental painting. I am convinced it is only the speed of acting that makes it possible to grasp and express that which comes out of the depths of one's being, without rational consideration and intervention holding back its spontaneous outburst." With this intention Mathieu indeed locates his painting process in the tradition of André Breton's definition of surrealist creations, and that artist's *écriture automatique*.

East Asian calligraphy was a further important inspiration for Mathieu. His compositions on monochrome backgrounds are also formally reminiscent of calligraphic symbols. The masters of Japanese calligraphy knew how to capture brush-written characters in a moment of utmost concentration on a sheet of paper. Behind their actions, however, were decades of training, practice, and experience.

Mathieu made these claims for his painting as well, and explained that in his spontaneous painting process, what came forth was something he had carried internally for years, completely formulating it there as an artistic idea.

Mathieu's painting performances were also a great public spectacle, however, which the artist carried out in Stockholm, Tokyo, and Düsseldorf in the following years. Though he did not influnce younger artists with his work, Mathieu's painting performances did anticipate important developments of the nineteen sixties. His move out of the isolation of the studio and his active preoccupation with the audience would also characterize the later actions of the Fluxus and Happening movements.

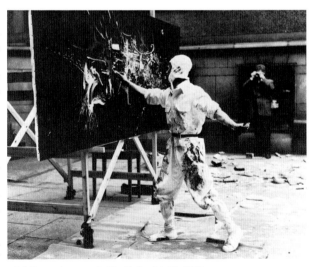

Painting performance in Stockholm, July 23, 1958

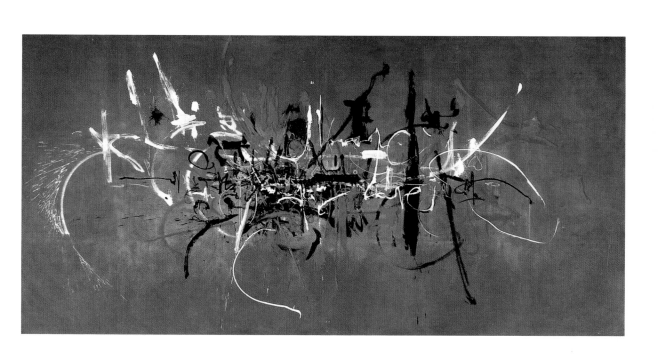

Rhythms in crimson and Grey II

Oil on canvas, 105 x 125 cm
Städel Museum, Frankfurt

b. 1902 in Berlin (Germany)
d. 1968 in Cologne

Ernst Wilhelm Nay was the most prominent artistic figure among the painters of German Informal Art. In 1937 at thirty-five years of age he was the youngest artist to have his paintings defamed in the Munich "Degenerate Art" exhibition. Despite this there was no disruption of his work followed by a new beginning after the Nazi period ended. Nay was one of the few artists to continue working secretly during the years when artists were politically persecuted. He developed his painting style continually from the late nineteen-thirties onward in series of works that followed each other in quick succession. Step by step, his early figurescapes thus developed into an ever more abstract formal vocabulary.

Rhythms in Crimson and Grey II from 1954 is from Nay's central series of disc paintings. The artist had begun them that year, developing them from his previous, so-called *Rhythmic Paintings*. In the following years the coloured discs were characteristic of Nay's compositions, and he kept his motifs completely planar. The discs proved to be perfect, self-sufficient forms, from which the artist omitted the dynamics of his earlier paintings. Colour dominated the pictorial surface as opposed to form, and the discs were the vehicle for colour. The colours float within the painting frame. Nay freed his compositions from traditional arrangements such as centre, edge, and perspective. His compositions only became animated in places where the painter positioned discs of related colours such that they direct the viewer's gaze in certain directions.

While *Rhythms in Crimson and Grey II* emphasizes the primacy of coloured discs, it is still a transitional work. Here the coloured triangles and quadrilaterals form a rising movement to counter the diagonals of the three dominating discs. Nay did not design the grey discs as precisely circular elements; instead they have slightly oval shapes that additionally emphasize the aspect of movement within the composition. The background is composed of large interlaced forms, which weave the entire motif into a dense structure. Thereby Nay created an equilibrium between the dark discs and flat areas on the one hand, and the seemingly transparent bright fragments of colour on the other. Not until the following year did he use these discs by themselves in his paintings.

"Naturally people spoke in public of nonsense, flowers, or balloons. Yet I had a primitive form in my hands, which was certainly suitable not only to serve as an allegory of life for the high spiritual requirements of a new arithmetical pictorial form, but also to give expression to the elementary powers of nature of the people today."

Ernst Wilhelm Nay

Large grey painting

Mixed media with sand on canvas, 195 x 169.5 cm
K 20 – Kunstsammlung Nordrhein-Westfalen, Düsseldorf

b. 1923 in Barcelona (Spain), lives in Barcelona

The path of self-taught Spanish painter Antoni Tàpies initially led him through a Surrealist-inspired phase before the artist found his own pictorial language in the early nineteen fifties. In 1950/51 he spent a year in Paris, furnished with a grant from the French state. There he became acquainted with the art of Jean Dubuffet and Jean Fautrier. The impasto of the surfaces of these artist's works thrilled the young painter from Barcelona, and inspired him to undertake his own experiments with materials. Tàpies began to mix his paints with clay, sand, chalk, marble dust, and cement. Into these paintings he assimilated the most diverse materials and found objects. More than almost any other artist he was successful in aesthetically integrating his diverse materials into a convincing overall composition. His canvasses condensed into massive, encrusted paintings, and he rubbed his coloured pigments into them more than applying them as paint. He scratched symbols in the impasto surface, or marked it – as in the *Large Grey Painting* – with a white cross form. Crosses repeatedly appeared in Tàpies' works, and over the decades they became a distinguishing feature in his paintings. Thereby this symbol in his work is by no means linked to Christian symbolism or a *memento mori*. Instead, Tàpies employed the cross as a sign of life: as an emblem and symbolic indication of the presence of humans. The indentations in the surface of the paintings function like individual graffiti, the artist's personal code inscribed on the painted supports that themselves look like hardened walls or facades.

Tàpies' works reveal a similar material handling as do the compositions of his German friend of many years, Emil Schumacher. On the other hand they stand in striking contrast to the transparent veils of colour of artists like Helen Frankenthaler. Tàpies' dark paintings are symbols of weightiness, seriousness, and melancholia. Unlike in paintings by his contemporaries, humans are always present in those of Tàpies'. In the works of Jackson Pollock, Franz Kline, Hans Hartung, and K. O. Götz it is the artist himself, his body, or his psychological state that the painting process transmits onto the canvas. In contrast, paintings by the Spaniard Tàpies are impressive metaphors for the existence of people. "With my work", said Tàpies, "I attempt to help people overcome the state of self-estrangement, in that I surround their daily lives with objects that confront them in a *tangible* manner with the final and deepest problems of our existence."

Matter on Wood and Oval, 1979

т 1956–9

Oil on canvas, 180 x 137 cm
Private collection, Paris

b. 1904 in Leipzig (Germany)
d. 1989 in Antibes (France)

In the nineteen twenties Hans Hartung studied at the art academies in Leipzig, Munich, and Dresden. His first exhibition took place in 1931 in Dresden, in the Heinrich Kühl Gallery. Four years later Hartung came into conflict with the new rulers of Germany and moved to France, where he fought in the Foreign Legion from 1939 until 1944 (until a serious wound resulted in the amputation of his right leg). In 1946 he was granted French citizenship. His first attempts at abstract painting date back to the nineteen twenties, but Hartung did not develop his characteristic pictorial language until after the war.

No other French painter's work can better be described as lyric expressionism. German Expressionism and French Surrealism were the most significant influences on his style of painting. Hartung further developed Surrealism's *écriture automatique* in his own manner, by condensing the automatic transcription of abstract gestures into a seismographic expression of inner emotional states. In this respect Hartung's approach was very different from that of the American Action Painters. The latter were interested in transferring onto canvas the movements of the body, unfiltered and unadulterated, while Hartung was after a visualization of his psychological state of mind on the painting support. He developed the compositions for his works in a state of the most extreme concentration and tension. The actual painting process was usually finished in a very short time. The result was a record of his momentary emotional state.

Hartung's paint application thus always seemed closer to drawing than painting. The brush marks move across the canvas like a nervous tremor. The titles of Hartung's paintings form a sober antithesis to the emotional process of their creation. The individual elements of the title *T 1956–9* stand for the French title of the painting series (*tableau*), the year it was created, and its sequential number within that year. The layout of its dark scaffolding of lines shifts continually against the light-coloured, spatially indistinct background. The motif appears to float within the picture plane. Hartung's compositions are reminiscent of East Asian calligraphy. Particularly as Hartung continued to develop his theme he also gained a sureness that pushed the aspects of painted automatism ever more into the background, making way for carefully composed stylistic innovation. At that point his compositions became not only more calculated, but also more elegant and decorative.

T 1962-U 4, 1962

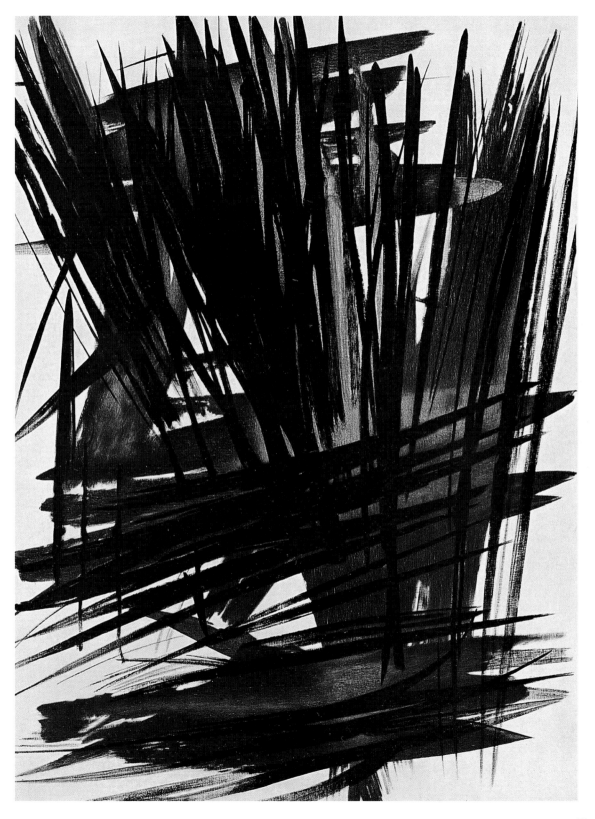

red, white and brown

Oil on canvas, 252.5 x 207.5 cm
Kunstmuseum, Öffentliche Kunstsammlungen Basel

b. 1903 in Dvinsk
(then part of Russia)
d. 1970 in New York/NY (USA)

Marcus Rothkowitz was six years old when his family emigrated to the United States for religious reasons. Later he Americanised his name to Mark Rothko and began studying at the renowned Yale University in New Haven. Rothko had his first solo exhibition in 1945 at Peggy Guggenheim's gallery Art of This Century. His work cannot be relegated either to geometric abstraction or to the Abstract Expressionism of his New York colleagues. In his compositions the colours' own values play the central role – one could say Rothko was actually a colourist in the tradition of British painter William Turner, and that he was a mystic of light.

Like no other artist of his generation, Rothko presented his works as a spatial experience. For his gallery exhibitions he selected formats that reached almost to the ceiling, and he filled all four walls of the rooms with his monumental formats. He refused to participate in almost all group exhibitions, and if he did participate in such shows he insisted on having his own room for his paintings. Rothko's ideal was to have a permanent public presentation in one room, comprising paintings he himself had selected. The small exhibition room at the Phillips Collection in Washington and the Rothko Chapel in Houston are two of the few examples where he was able to realize this ambition. The designation "chapel" already points to the way Rothko wanted his work to be experienced. Viewers should be able to open themselves to the works, and submerge themselves in the colours. The light should reflect the colour and thus transfer it into the room. The narrowness of some exhibition spaces and the oppressive size of the paintings must have made some viewers feel virtually enclosed within the paintings. Rothko consciously provoked this kind of experience. He once declared, "I also hang the largest pictures so that they must be first encountered at close quarters, so that the first experience is to be within the picture."

In *Red, White and Brown* Rothko layered the three zones of colour to create an atmospheric red colour space. The three colours red, white, and brown are arranged in a vertical structure. The light white zone below and heavy brown above produce a reversal of weight, and the colours seem to float. Rothko laid out each of the three colours differently. At its edges, the narrow white rectangle blends into its red surroundings, while the orange-red form lying above this produces a delicate transition to the atmospheric colour space. While keeping both colour zones fairly monochrome he applied the upper brown colour in a lively manner, so it appears to be of various thicknesses and in places allows the red beneath it to shine through.

The year in which he produced this composition, 1957, was a turning point in Rothko's work. Looking back he was able to state: "I can only say that the dark pictures began in 1957 and have persisted almost compulsively to this day." Before Rothko's suicide in February 1970, his palette was in fact completely dominated by dark black and grey tones.

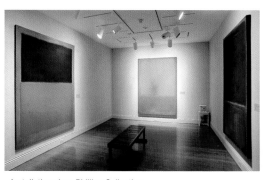

Installation view, Phillips Collection

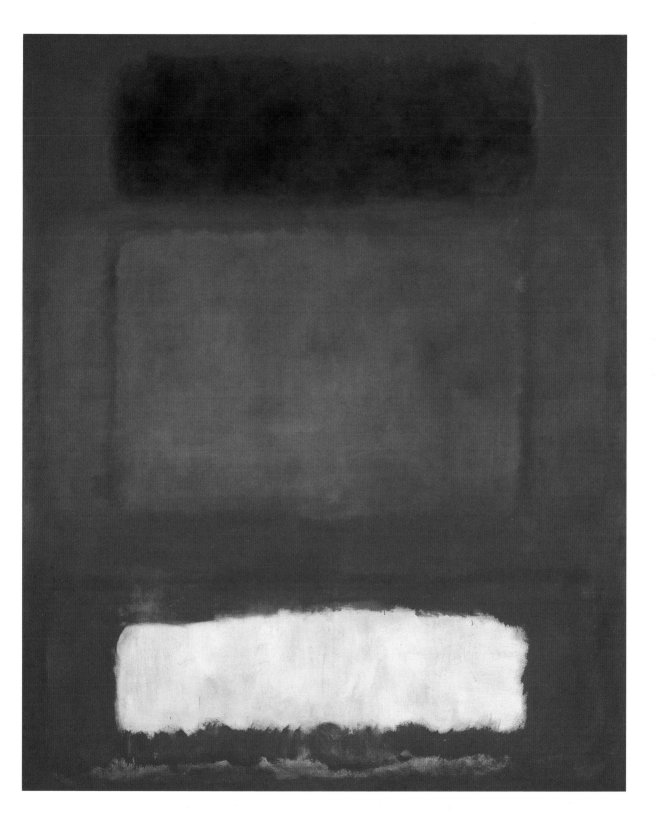

painting 7 ɪuly 1957–1958

Oil on canvas, 89 x 130 cm
Sprengel Museum Hannover, Hanover

b. 1919 in Rodez/Aveyron (France), lives in Paris

Before coming to Paris in 1946, Pierre Soulages earned his living as a simple farm worker. In that city the self-taught artist spent all his time on his painting. Soulages is the central figure of the French École de Paris. In contrast to Hans Hartung's psychological automatism and eruptive brush marks, Soulages produced arrangements of black bars. While the work of the former expresses nervous gesture, the latter's manifests a restive, interlocking form. In this way Soulages' works resemble those of his American contemporary Franz Kline, whom he had also personally met early on. Soulages once reported how incisively his 1946 arrival in Paris had impressed him, and how it had been stimulating for all of his work from then on: "On my arrival in Paris in the Gare de Lyon I remember a glass roof that had been repaired with tar, as it was shortly after the end of the war. The broad, raw brush strokes of the labourers who had worked on it enthralled me."

Painting 7 July 1957–1958, although painted more than a decade after this experience, still seems to have been created under this impression. The picture comes alive due to the blocky areas of impenetrable black, the transparency of the colours, and the bright light. Soulages applied the paint here in numerous layers and broad stripes. The painting consists solely of horizontal and vertical forms. Thereby, Soulages always respected the format of the painting support.

His painting rests in the picture plane with a distinctive middle point at its centre. The broad bars make the picture seem like a monumental architectural construction, although the distinctive bright section at the composition's lower edge also gives the painting a certain feeling of weightlessness. Only in the upper layers does the black coalesce into an opaque, impermeable form. In other areas of the composition it becomes permeable.

The blue employed in places mediates between the contrasts of black and white. Light appears to shine through the layers of black. The black beams lie like zones of shadow in front of the light background. Light was to take on preeminent significance in the artist's late work. In those completely monochrome compositions the structure of parallel lines on the surface only becomes visible at all due to the light breaking through at their tips.

Painting 222 x 157 cm, 23 November 1984

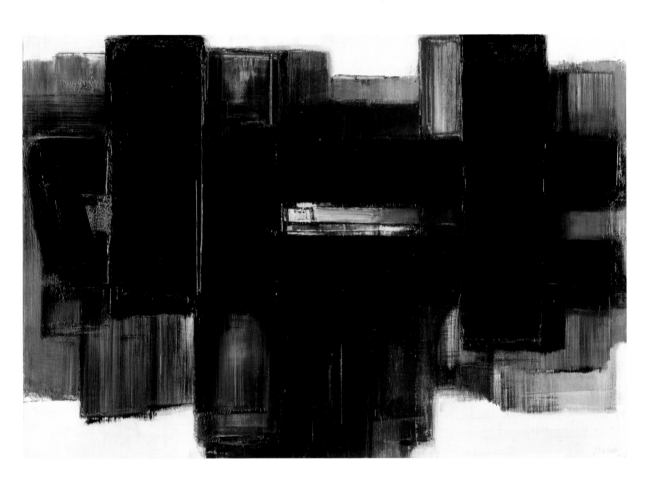

Abstract painting

Oil on canvas, 274.5 x 101.6 cm
Fukuoka Art Museum

b. 1913 in Buffalo/NY (USA)
d. 1967 in New York/NY

Ad Reinhardt was enrolled from 1931 until 1935 at Columbia University in New York to study art history, which he followed in 1936 with practical training as a painter. Unlike most of his artist comrades of the New York School, Reinhardt accompanied his artistic works with extensive theoretical reflections. In the early nineteen fifties he eliminated visible brush strokes and bright coloration from his paintings. After that, Reinhardt continually reduced his compositions. Henceforth he laid out all of his formats solely using geometric planes in shades of red, blue, and black, differing from one another only in nuances. From 1960 until his early death in 1967 Reinhardt only painted square pieces with edges 60 inches (152.6 cm) long. Viewing his painting style as lying within the tradition of Malevich's *Black Square* and Piet Mondrian's austere compositions, Reinhardt and his paintings became the most important influence for a younger generation of minimal and conceptual artists. As early as 1961 the young Frank Stella, after his own first successes, had already acquired one of these *Black Paintings* from Reinhardt.

In a talk held in Detroit in 1957, Reinhardt claimed, "The more uses, relations, and 'additions' a painting has, the less pure it is. The more stuff in it, the busier the work of art, the worse it is. More is less." In the latter sentence he thereby varied a famous dictum by the architect Ludwig Mies van der Rohe ("Less is more"). Reinhardt propagated a style of art that constantly decreased its vocabulary of forms, becoming more and more reductive, yet above all becoming more concentrated. While in the late nineteen fifties he still accepted the use of various monochromatic tones of blue and red, later he concentrated solely on the colour black. Apart from light nuances of tonal value, one could even say that after 1960 Reinhardt only painted the same *Black Painting* again and again. He created the painting illustrated here in 1958, thus two years before those radical last works.

The composition on the narrow, extremely tall canvas consists of twenty-one light-coloured rectangles parallel to the pictorial surface. The planes differ from one another because Reinhardt mixed nuances of yellow, blue, and red into the pure black. On the picture plane these different values of black are arranged beside one another as if to create an impression of overlapping transparent ribbons. The layers of paint are applied to the smooth texture of the canvas extremely thinly, so that the individual rectangles show neither brush strokes nor shades. On the dull black surface, however, Reinhardt's shadings swallow the light to such an extent that their soft graduations are barely visible. These paintings are therefore a challenge to their viewers' sense of vision. Only with the necessary willingness and through meditative concentration does the composition's structure appear at all out of the impenetrable surface. Thereby Reinhardt rejects all symbolic interpretation of the black used in his paintings. For him the non-colour black was just an artistic challenge. In a statement he made in 1958, the year he created the *Abstract Painting* depicted, he formulated his prime postulate: "Art is art. Everything else is everything else."

Flying Heads

Oil on canvas, 97 x 130 cm
Essl Collection, Klosterneuburg

**b. 1921 in Amsterdam
(Netherlands)
d. 2006 in Zurich (Switzerland)**

During the war Karel Appel studied from 1940 to 1943 at the Rijksakademie van Beeldende Kunst in his native city of Amsterdam. In 1948, together with the painters Corneille and Constant, he was one of the founding members here of the Dutch group Reflex. Appel proved above all to be an energetic communicator. Thus in the same year the regional group became the international COBRA movement with centres in Copenhagen, Brussels, and Amsterdam (the first letters of which formed the group's name). In the following year Amsterdam's Stedelijk Museum held the first large exhibition of the group's work. In the same year Appel jotted down his artistic credo: "To paint means to destroy everything that existed previously."

The COBRA artists' paintings were created in direct reaction to the war that had just ended, and to the horrors they had survived. The destructive element, the grotesque and demonic, had impressed itself deeply into these paintings' motifs. Appel was impressed by works of Kurt Schwitters, Paul Klee, and Max Ernst. In his works he succeeded in balancing abstract gesture and figurative representation. With the tormented and appalled faces Appel formulated an existential expression – something Willem de Kooning had managed to do in his *Woman* series on a much more aesthetic level. Appel did not use the means of his painting style to illustrate the figures; instead the mouths and eyes of faces emerge out of the mass of colour. The paint does not become illustrating colouration, but instead remains present as a coloured pigment. The paint application is impasto, aggressive, and exuberant. One gets the impression Appel was trying to put more paint on the canvas than it could hold. Thereby he always managed to retain a feeling of calculated design.

This was especially true for the two depictions of *Flying Heads* he produced in 1959 which are not intended to be read as individualised portraits. On the contrary, the heads are almost lost in a veritable whirlpool of thickly applied masses of paint. Indeed, in only a few places on the canvas did Appel use a brush to apply his paints. Generally he used a palette knife or squeezed the paint directly from the tube onto the pictorial surface. Thirty years after painting this picture Appel still spoke of the difficulties of his artistic process: "Over the years I have learned how I have to apply oil paint on the canvas. I can now make the paint do what I want it to. But it is still a fight, a struggle."

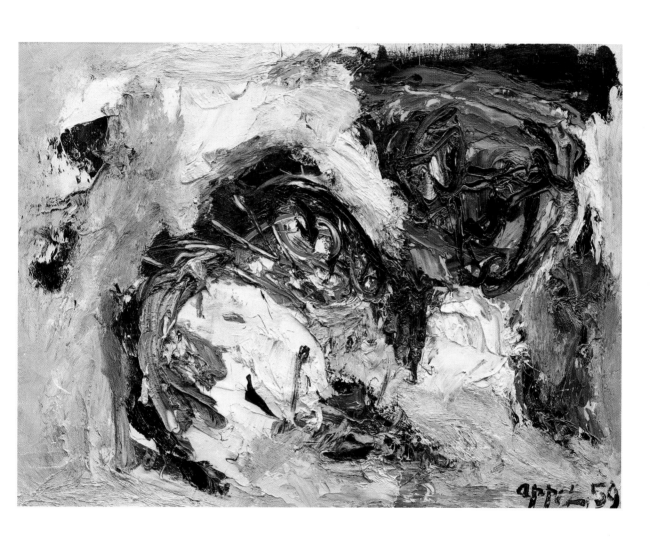

Die Fahne hoch!

Enamel paint on canvas, 308.6 x 185.4 cm
Whitney Museum of American Art, New York

b. 1936 in Malden/MA (USA),
lives in New York/NY

The large-format painting *Die Fahne hoch!* [The Flag on High!] by Frank Stella confronts viewers with such power, consistency, radicality, and self-assuredness that one is inclined to see it as the pinnacle of a lifelong artistic development. When the painter first presented the work in December 1959 at the New York Museum of Modern Art's exhibition "Sixteen Americans", he was only twenty-three years old, and had just finished studying at Princeton University. Stella's *Black Paintings* of this year formulate an extreme artistic position from which he progressively freed himself in the years that followed. While in the first versions of his *Black Paintings* he still positioned the bands of paint parallel to the edges of the paintings, in later motifs of the so-called *Diamond Pattern* series they run at an angle of forty five degrees. Not until a later phase did Stella give up black completely and begin using a metallic aluminium paint. At the same time he reversed the hierarchy between painting support and motif, in that the painting support's exterior contour now followed its interior pattern of stripes.

In the New York art scene at the end of the nineteen fifties Stella's concentration on the non-colour black in his *Black Paintings* was no longer provocative. Robert Motherwell, Jackson Pollock, and Franz Kline had already produced black compositions. Stella's works, however, were radically different and new. At the centre of the canvas two light-coloured lines form a cross. Stella painted right-angled black bands, approximately eight centimetres wide, at close intervals. There are only horizontal and vertical bands in this painting, and they always run parallel to one another. Stella explicitly attempted to avoid painterly perspective, and the width of the black stripes was another way to achieve this. For although he applied the black paint to the unpainted canvas, which shows through as white lines between the black bars, traditional seeing habits cause viewers to initially perceive the motif as narrow light-coloured lines on a black background. While one could speak of painterly illusionism in this respect, this actually reverses the relationship of figure and ground here, thus simply emphasizing the painting's flatness. "What you see, is what you see" was Stella's most famous and often repeated statement regarding his paintings. This formulation refers to the anti-illusionistic character of his pictorial concept.

Stella's painting style denies all interpretations that go beyond visible form. The imagery is not symbolic and it negates the idea of a painting as a view out a window onto a world view created by the artist. Stella consciously avoided using traditional oil paint and preferred industrial enamel paint. At eight centimetres, the stretcher frame was exactly the same depth as the width of the black stripes, making the picture plane into a picture box.

In this context only the piece's German title is confusing. *Die Fahne hoch!* quotes the first line of the notorious Nazi "Horst Wessel Song". As another painting title Stella selected the words *Arbeit macht frei*, the cynical inscription over the gate at the concentration camp Auschwitz. Stella himself, who studied history at Princeton, spoke of the repressive political atmosphere such titles expressed, and that he wanted them to be understood as personal associations, but by no means as interpretive approaches for viewers. In view of the portentousness of such titles, however, a contradiction remains.

situation clash 59–6

Oil on canvas, 275 x 214 cm
Städtisches Museum Leverkusen, Schloss Morsbroich

b. 1919 in Venice (Italy)
d. 2006 in Venice

Emilio Vedova was the leading personality of abstract painting in Italy. Younger artists also joined numerous groups here, rallying to the catchphrase "abstraction as world language". For only about a year, in 1952/53, Vedova participated in the so-called Gruppo degli Otto. The rest of the time he remained a loner, and even his place of residence in Venice, far from the country's artistic centres, emphasized his isolated position.

Vedova's painting style was characterized by black and white compositions. Like Franz Kline the artist emphasized the equivalence of these two non-colours, so that the paintings were certainly not just black compositions on a white background. Black and white practically battle one another on Vedova's canvases, accompanied by the other colours, especially red and blue. He applied the colours wet in wet, causing them to mingle and obscure each other. The surfaces had no clear structure, no direction, and no centre. Vedova applied his paints impetuously and with forceful gestures. Everywhere on the canvas small junctures formed where the colours seemed ready to burst away from each other in an explosion. The monumental *Situation Clash 59–6* is one of Vedova's characteristic compositions. The title emphasizes spontaneity, contradiction, and openness in the painting process. In 1959, the year he created this work, the Italian artist was represented at documenta in Kassel for the second time since 1955.

Vedova had always understood his painting practice to be partly political, without thereby taking recourse to a realistic or illustrative mode of representation. Many of his abstract works, which were often created in extensive painting cycles *(ciclo)*, refer to political themes in their titles. While on a scholarship in Berlin in 1964 he created the *Absurdes Berliner Tagebuch* [Absurd Berlin Diary], an installation of several freestanding wooden panels painted on both sides, following the example of medieval folding altars. Vedova named these paintings in space *Plurimi* (approximately: multi-sectional) and described them as "objects that like powerful weapons were bred to be aggressive symbols, which could no longer remain in the static dimensions preconceived by the painting (passive surface), outlined by only one person, the painter."

Scenes of Berlin are not to be found on the panels. The aggressive and rough paint application, however, awakens associations of the divided, inwardly divergent city. Dispersed freely in space, the pictorial elements also bring to mind the heavy anti-tank obstacles set up at inner German border crossings.

scranton

Oil on canvas, 177 x 124.5 cm
Museum Ludwig, Cologne

b. 1910 in Wilkes-Barre/PA (USA)
d. 1962 in New York/NY

The localities and landscape of his hometown Wilkes-Barre repeatedly found their way into Franz Kline's paintings. After training as an artist in Boston and in London, Kline moved to New York in 1950. Impressed by the works of Willem de Kooning, he gave up his representational painting style and found his way to his abstract pictorial language. Kline's compositions are reduced to monumental symbols and clear black and white contrasts.

In the nineteen fifties the New York School had started a real tradition of black paintings. Mark Rothko, Jackson Pollock, Ad Reinhardt, Frank Stella, and even Robert Rauschenberg had created series, some very extensive, of so-called Black Paintings. Thereby Kline differentiated his position from those of the other artists, because – as he explained – he by no means painted black, but black and white paintings. For he employed white as well as black: "People sometimes think I take a white canvas and paint a black sign on it, but this is not true. I paint the white as well as the black and the white is just as important."

Kline thus composed his works as an interplay of layers of paint overlying each other, in which black and white alternately and repeatedly obscure one another. The black symbol nevertheless dominated in the end. Viewers always perceive it as a shadowy form against a light-coloured ground. With a similar argument Kline once protested the fact that critics compared his painting with East Asian calligraphy. For by no means, he said, was he designing a monumental black symbol in an expansive gesture on the canvas. Instead Kline emphasized the multilayered and sublime painterly character of his paint application. Thereby the white planes, he said, were more than just a light-coloured ground coat on the canvas. Yet this would only become obvious to viewers who carefully examined the original. Reproductions only convey an inadequate impression of this. Only then would the viewer see how the white was delicately modulated and constructed of shaded layers, and that Kline's black could also be divided into matte and glossy sections.

The powerful monumental brush strokes in Kline's paintings were not based solely on fervent spontaneity; he first designed and tested numerous compositions in a smaller format before transferring them – surprisingly faithful to the original – onto the larger canvas. Many of these works appear to have been inspired by his recollections of the crane and winding-tower architecture of his Pennsylvania home. The titles of other works refer to places from Kline's childhood, such as this picture entitled *Scranton*, named after a Pennsylvanian city.

"The thing is that a person who wants to explore painting naturally reflects: 'How can I in my work be most expressive?' Then the forms develop."

Franz Kline

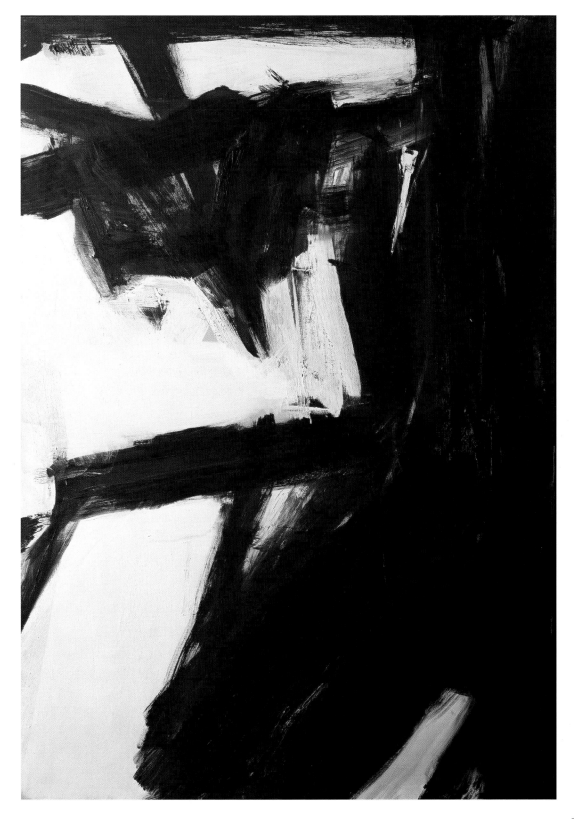

Door to the River

Oil on canvas, 203 x 178 cm
Whitney Museum of American Art, New York, Purchased with funds from the Friends of the Whitney Museum of American Art 60.63

**b. 1904 in Rotterdam (Netherlands)
d. 1997 in East Hampton/Long Island (USA)**

After finishing his studies at the art academy in Rotterdam Willem de Kooning arrived in the United States in 1926, and from 1936 onwards dedicated himself solely to painting. In 1942 he became friends with Jackson Pollock in New York. Just eight years later he created the large-format painting *Excavation*, which some critics still consider the artist's masterpiece. The large-format composition unites the expressive power of Abstract Expressionism with an abstracting figurative stylistic idiom. Fragments of figures clearly stand out amongst a web of black lines on a yellow-toned ground, with splashes of colour. In his next series of work, the six so-called *Women* portraits, De Kooning intensified the ambiguity between expressive painterly gesture and figurative form. Colour presents itself more dramatically here. It spreads across the canvas almost explosively. A few prominently placed black brush strokes and coloured accents indicate the curves of a female body. The woman's face is somewhat more precisely integrated into the abstract whirl of colour.

De Kooning worked for almost four years on the six paintings, which he repeatedly overpainted and corrected during that time. When the group was finally exhibited in the Sidney Janis Gallery in 1953 under the rather harmless title "Paintings on the Theme of the Woman", they caused a scandal. De Kooning shocked colleagues, critics, and the public not only because of the caricature he was presenting of his female models, but also by bringing figurative depiction back into the abstract repertoire of forms. De Kooning later justified himself to his critics as follows: "Certain artists attacked me for painting the *Women*, but I felt that this was their problem, not mine. I don't really feel like a non-objective painter at all."

He produced *Door to the River* seven years after this scandal. It is a much more clearly convincing example of Abstract Expressionism and of American Action Painting. The composition consists of a few powerfully contrasting strokes of colour. Although the work is a good two meters tall, De Kooning applied his paint with dynamic brush strokes worked across the entire breadth and height of the canvas. The complete spontaneity of the painterly process can still be read in the result. He applied the paint wet in wet, and unlike his painstakingly worked out compositions of the *Women* series, here De Kooning seems to have placed his colours and gestures with the assuredness of a sleepwalker. Only the title of the work, *Door to the River*, still hints at representational or landscape connections. To De Kooning himself such associations may have been useful in laying out his abstract compositions, but for viewers they are no longer identifiable in the painting. In the nineteen fifties de Kooning was the most important antithesis to Pollock, and after his early death in 1956 De Kooning undisputedly became the leading figure of American Abstract Expressionism.

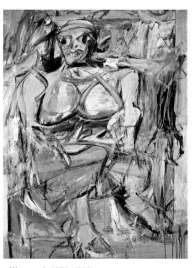

Woman, I, 1950–1952

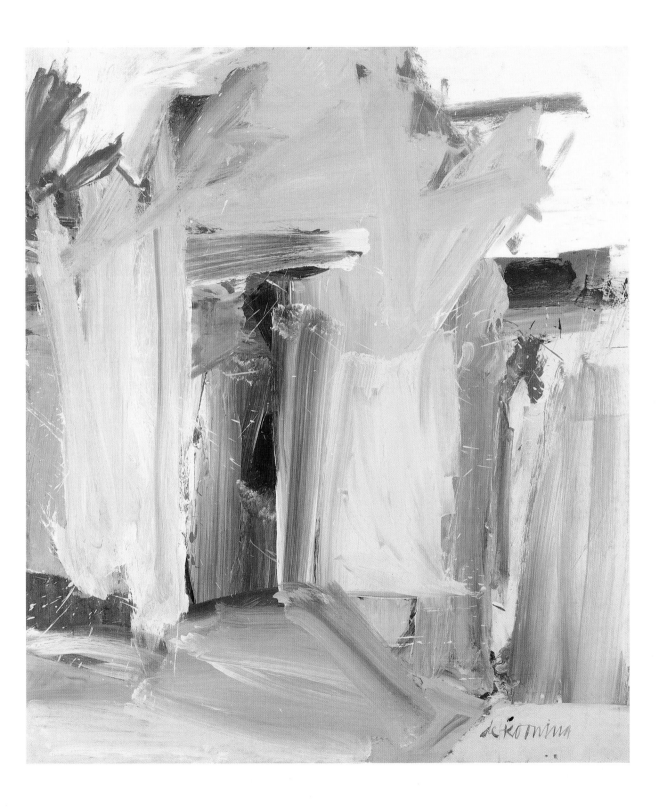

Rofos

Oil on canvas, 100.5 x 61 cm
Städtische Kunsthalle Recklinghausen

b. 1912 in Hagen (Germany)
d. 1999 in San José/Ibiza (Spain)

"I approach the painting like I approach a wall, in order to find a gap through which I can enter, to get behind the unknown of the boundary. Once I have achieved it, it is no longer a secret and a new wall arises before me." With these words Emil Schumacher described his studio work in 1960. For Schumacher the painting process was not theoretical, but primarily physical and sensory. Armed with the tools of painting he approached the canvas or wooden panel. Thus numerous works exist in which Schumacher actually broke through the painting support. He destroyed the surface and expanded the picture plane into becoming a painted object. Even the name of the series of so-called hammer paintings indicates how much boisterous strength the artist sometimes subjected his painting supports to.

Completely unlike the disc paintings by Ernst Wilhelm Nay, form and colour in Schumacher's works are borne by the material. He applied the paint thickly and often directly with his hands onto the painting support. He mixed his paints with sand, fabric, and lumps of asphalt. Schumacher's artistic model was nature, yet far from attempting an intellectual assimilation of the material, he instead sought the vitality of nature through his painting. The surfaces of his paintings have a crusty, haptic quality. During the early nineteen sixties he created, as an independent series, a few so-called touch objects that encouraged viewers to touch the pictorial surface.

The painting *Rofos* is a typical example of Schumacher's work. The title has no concrete meaning, even though the titles of his painting often recall the names of exotic places. Actually, as is also the case here, Schumacher selected abstract, purely onomatopoeic formulations as his works' titles. The surface of this canvas looks like a compact, fractured layer of rock. A strong dark red colour flows into the image from the painting's left edge, taken up in other areas by a few traces, seeming almost accidental, of red paint. The high black arc already appears here too, although it is not yet as central to the painting as it would become in his later work. In the composition *Rofos* it is the most conspicuous form. It gives pictorial structure and compositional stability to the informal surface. The arc inscribes itself in the underlying painted layers like an anarchistic symbol. It is simultaneously both landscape and architectural abbreviation, and is reminiscent of the shape of a mountain or hut. In *Rofos* the picture plane is divided by a centrally placed horizon line, which freely reflects the arc motif again in the painting's lower half. Schumacher once answered the question about the position of his painting practice as follows: "In any event closer to the earth than to the stars. Thus thoughts of landscape arise: Above and below, the line of the horizon. They are not landscapes; but how could I escape nature?"

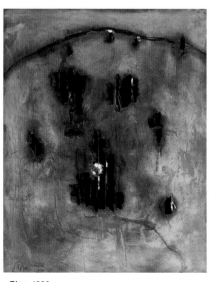

Bing, 1966

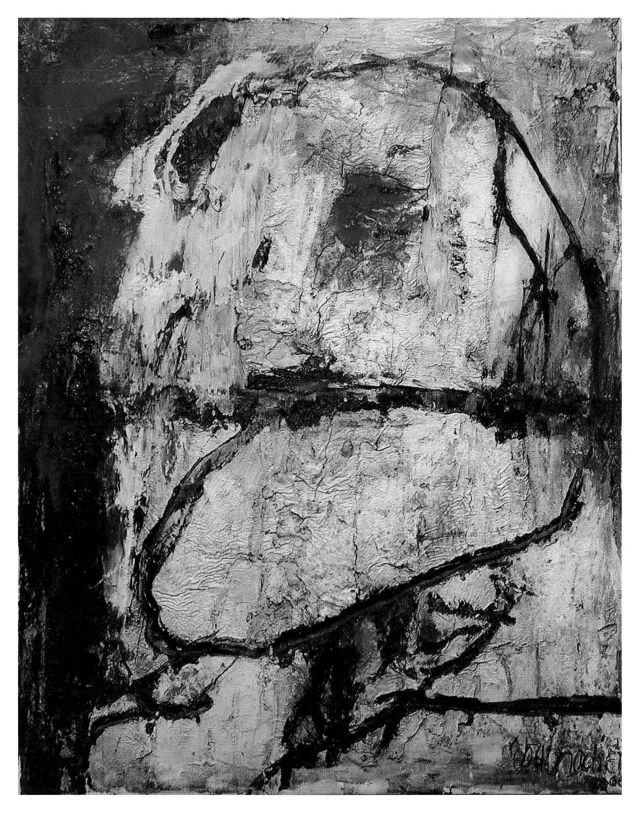

Noon

Synthetic polymer paint on canvas, 296 x 222 cm
Sprengel Museum Hannover, Hanover

b. 1928 in New York/NY (USA),
lives in New York/NY

Helen Frankenthaler was one of the few women artists able to assert herself in the New York art scene of the nineteen fifties. Between 1945 and 1950 she studied in various art schools in Vermont and New York. After visiting an exhibition by Jackson Pollock in the Betty Parsons Gallery in 1951, she developed her own individual painting technique and pictorial language. From Pollock she took the method of laying the canvas on the studio floor and pouring paint onto its surface. Thereby it was important that the canvas remained unprimed, and that the paint be very liquid when applied. This allowed the painting support to literally absorb the paint. Frankenthaler also rubbed the paint into the canvas with a sponge. The result of this was that the canvas no longer served as an underground for the painting, but became the bearer of colour. This was a fulfilment of the renunciation of all illusion and three-dimensionality in painting as demanded by critics such as Clement Greenberg.

Compared with the works of her contemporaries, Frankenthaler's compositions convey a completely unique experience to viewers. While in the works of Pollock, Willem de Kooning, Franz Kline, and Robert Motherwell the perception of paint on the canvas is always connected with the physical gesture of its application, in Frankenthaler's works the colours take on a previously unknown dynamic of their own. Her colours appear to flow on the surface and to find their arrangements as if by chance. With this type of process the reverberations of surrealistic automatism can also be felt in Frankenthaler's work. Frankenthaler later reminisced about the beginning of her painting practice: "I had no desire to copy Pollock. I didn't want to take a stick and dip it into a bucket of enamel paint. I needed something more fluid, watery, thin. Throughout my life I have felt drawn to water and transparency. I love the water; I love to swim, to observe the changing ocean." Frankenthaler's early works of the nineteen fifties, with their light, transparent colouration that gives her compositions a lyric quality, confirm this characterization.

She created *Noon* in 1966, and it is thus no longer one of her early works. The composition possesses a powerful colour scheme comprising green, orange, and white tones. It is a particularly convincing example of how Frankenthaler incorporated unprimed canvas into her compositions of the nineteen sixties. Here it even dominates the painting's monumental, almost three meter high surface. With her unprimed, stained canvases, Frankenthaler had an important influence on the younger generation of American artists, including Colour Field painters like Morris Louis, Jules Olitski, and Kenneth Noland.

Kenneth Noland, Bloom, 1960

who's Afraid of Red, Yellow and Blue I

Oil on canvas, 190.5 x 122 cm
Private collection, New York, New York

b. 1905 in New York/NY (USA)
d. 1970 in New York/NY

Not until quite late did Barnett Newman receive the art historical recognition his work deserved. The native New Yorker studied in New York at the Art Students League and at City College. In 1940 he even destroyed all of his early work. His first exhibitions in the renowned Betty Parsons Gallery in the early nineteen fifties were a fiasco with the press and the public; for a long time Newman was more esteemed as an exhibition curator and author with wide interests. From him originated, among other things, the astute aphorism that aesthetics mean as much to an artist as ornithology does to a bird.

Between 1966 and 1970 he created the group of four paintings entitled *Who's Afraid of Red, Yellow and Blue*. They form the magnificent high point in Newman's work, and the artist died the year he completed the final painting. Two of the paintings are portrait format, while the other two are monumental landscape format. The final picture, now in the Neue Nationalgalerie Berlin, is the largest version and measures more than six meters across, with a height of 274 cm. The example illustrated here is the first painting of the group, produced in 1966. Two others are also in private collections, and one is in the Stedelijk Museum Amsterdam. All four consist of colour fields divided vertically into planes of the three primary colours red, yellow, and blue, whereby the powerful red dominates the other colours in each work. Only in the monumental final version do two identical red and yellow planes stand opposite each other, divided by a narrow, centrally placed bar of blue.

Newman always attached special significance to his paintings' formats. More than in the work of almost any other artist, in Barnett's work they are an essential component of the visual experience. Therefore Newman also exploited their possibilities as far as he could. The late Berlin canvas is Newman's largest format ever. He created his smallest painting at the beginning of his work. Produced in 1950, it measures just 4.1 cm wide, but with a height of 243 cm. *The Wild*, as it is entitled, is a narrow red strip that treats the surface of the wall on which the canvas hangs like a pictorial surface. Newman refers to it as a "zip", like the zipper in clothing, a narrow vertical strip of colour that separates the generous colour fields from one another, but that also connects them together. Newman described the "zip" as "a field that brings life to the other fields, just as the other fields bring life to this so-called line."

In the first version of *Who's Afraid of Red, Yellow and Blue*, "zips" like these border the edges of the dominant red plane. They intensify the red's visual power, so that the colour takes on a physical presence for viewers. The considerably broader blue bar thereby forms an exact line with the red, while the narrow yellow strip has an irregular contour. The painter's personal style of line contrasts here with the perfect surfaces of the colours. The unusual title of these paintings plays on the psychological quality of the colours, and particularly on the aggressive effects of red. Indeed, the two large-format works in the Berlin and Amsterdam public collections have provoked baffled visitors to such an extent that both paintings have already been attacked and badly damaged.

To stay informed about upcoming TASCHEN titles, please request our magazine at www.taschen.com or write to TASCHEN America, 6671 Sunset Boulevard, USA–Los Angeles, CA 90028, Fax: +1-323-463.4442. We will be happy to send you a free copy of our magazine which is filled with information about all of our books.

© 2008 TASCHEN GmbH
Hohenzollernring 53, D–50672 Köln
www.taschen.com

Editorial coordination: Sabine Bleßmann, Cologne
Design: Sense/Net, Andy Disl and Birgit Reber, Cologne
Production: Ute Wachendorf, Cologne
Translation: Sean Gallagher, Nanaimo

Printed in Germany
ISBN 978-3-8228-5620-8

Photo credits:
The publishers would like to express their thanks to the archives, museums, private collections, galleries and photographers for their kind support in the production of this book and for making their pictures available. If not stated otherwise, the reproductions were made from material from the archive of the publishers. In addition to the institutions and collections named in the picture descriptions, special mention is made of the following:
© Archiv für Kunst und Geschichte, Berlin: p. 7, 9 left, 13, 27, 29, 81

Archives of American Art, Smithsonian Institution, Washington D. C.: p. 22 left (photo: George Platt Lynes)
Artothek, Weinheim: p. 8, 29 (photos: Peter Willi) 31, 33 (photo: Blauel/Gnamm), 69 (photo: Ursula Edelmann), 75 (photo: Hans Hinz)
Bildarchiv Preußischer Kulturbesitz, Berlin: p. 60, 62
Kunsthalle Recklinghausen: p. 91
Kunstsammlung Nordrhein-Westfalen, Düsseldorf: p. 71, 92 (photos: Walter Klein)
Museo civico e archeologico, Castello Visconteo, Locarno: p. 49
Museum Morsbroich, Leverkusen: p. 85
Museum Sztuki, Lodz: p. 55
© Photo SCALA, Florenz/The Museum of Modern Art, New York 2008: p. 57
Kurt Schwitters Archiv im Sprengel Museum Hannover: p. 45
Sprengel Museum Hannover: p. 17 right, 41, 77, 93
Stedelijk Museum, Amsterdam: p. 43
Stiftung Hans Arp und Sophie Taeuber-Arp e. V., Remagen-Rolandseck: p. 48
Stiftung Saarländischer Kulturbesitz, Saarlandmuseum Saarbrücken: p. 63 (photo: Carsten Clüsserath)
Rheinisches Bildarchiv, Cologne: p. 87
Whitney Museum of American Art, New York: p. 83

Reference illustrations:
p. 30: Robert Delaunay, *Circular forms*, 1930, oil on canvas, 129 x 195 cm, The Solomon R. Guggenheim Museum, New York
p. 36: Kasimir Malevich, *Airplane in Flight*, 1915, oil on canvas, 57.3 x 48.5 cm, The Museum of Modern Art, New York
p. 48: Sophie Taeuber-Arp, *Composition Aubette*, ca. 1927, relief, cardboard, painted, 57 x 38 cm, Stiftung Hans Arp und Sophie Taeuber-Arp, Bahnhof Rolandseck
p. 52: Piet Mondrian, *Composition 10 in Black-and-White*, 1915, oil on canvas, 85 x 108 cm, Rijksmuseum Kröller-Müller, Otterlo
p. 60: Wols, *Yellow Composition*, ca. 1947, oil, grattage, impression of tubes on canvas, 73 x 92 cm, Staatliche Museen Preußischer Kulturbesitz, Neue National-galerie, Berlin
p. 62: Karl Otto Götz, *Painting of Feb. 5, 1953*, 1953, mixed media on canvas, 125 x 90 cm, Staatliche Museen Preußischer Kulturbesitz, Neue Nationalgalerie, Berlin
p. 70: Antoni Tàpies, *Matter on Wood and Oval*, 1979, mixed media on wood, 270 x 220 cm, Private collection
p. 72: Hans Hartung, *T 1962-U 4*, 1962, oil on canvas, 180 x 111 cm, Private collection
p. 76: Pierre Soulages, *Painting 222 x 157 cm, 23 November 1984*, oil on canvas, 222 x 157 cm, Galerie 1900–2000, Paris
p. 88: Willem de Kooning, *Woman I*, 1950–1952, oil on canvas, 192.7 x 147.3 cm, The Museum of Modern Art, New York
p. 90: Emil Schumacher, *Bing*, 1966, oil on wood, 126 x 99 cm, Private collection, Meerbusch
p. 92: Kenneth Noland, *Bloom*, 1960, acrylic on canvas, 170 x 170 cm, Kunstsammlung Nordrhein-Westfalen, Düsseldorf

page 1
KASIMIR MALEVICH

Suprematistic Composition
1915, oil on canvas, 49 x 44 cm
Wilhelm-Hack-Museum, Ludwigshafen

page 2
PIET MONDRIAN

Painting 3 with orange-red,
yellow, black, blue and grey
1921, oil on canvas, 49.5 x 41.5 cm
Kunstmuseum Basel

page 4
MARK ROTHKO

The Green Stripe
1955, oil on canvas, 170.2 x 137.2 cm
The Menil Collection, Houston